Wang Dehui
Oil and Chinese Brush Paintings

王 德 惠 畫 集

Edited with a Preface by Lien Chao, Ph.D

趙 廉 博士 編

Library and Archives Canada Cataloguing in Publication

Dehui, Wang, 1924-
 Wang Dehui : oil and Chinese brush paintings / edited with a preface by Lien Chao.

Includes bibliographical references.
Texts in English and Chinese.
ISBN 978-1-894770-44-6

 1. Dehui, Wang, 1924-. I. Chao, Lien, 1950- II. Title.

N7349.D44A4 2008 759.951 C2007-906874-X

TSAR Publications
P. O. Box 6996, Station A
Toronto, Ontario M5W 1X7
Canada

www.tsarbooks.com

Contents　目録

Preface

From Natural to Supernatural: Wang Dehui's Artistic World

In the early spring of 1994, I had an opportunity to view the solo exhibition of Mr. Wang Dehui's Chinese brush paintings. Dehui was a visiting artist from Hangzhou, China, and the exhibition was held at the Contemporary Chinese Art Gallery in Toronto. Thirteen years later, tracing my feelings back to the first time viewing Dehui's artwork, I can still remember the moment of being completely refreshed by his unique style, which has been difficult to forget to this day. His Chinese brush painting belongs to the category of "freehand ink brushwork of great expression"[1]. The subjects in his paintings cover a wide range, such as landscape, flora, animals, figures, and so on. His style blends simple structures, strong brush lines, and vivid colour expressions. In some paintings, he utilized only a few brushstrokes to mix in colour, ink and water, leaving viewers ample space for imagination.

Since then, I have been watching the development of Dehui's art with great interest.

In 1999, I heard that upon the invitation from the "International Art City" in Paris, Dehui went to Europe for a half-year research tour. During this time, he became a young artist again; carrying his sketch board, brushes, water, and food on his back, he would leave his residence early in the morning to paint on the streets until late at night each day. Dehui had studied oil painting in his earlier career; however, during his stay in Europe, he expanded his style and creative language. With a production of several hundred oil paintings from this period, he has left his imprints in France, Italy, Holland, Belgium, Austria, and Spain. His portfolio shines with strong personal style of bright colours, dramatic composition, passionate brush strokes, and sometimes a trace of stubbornness usually found in kids' drawings. Dehui's bold use of the original colours breaks through the pursuit of delicate details from generations of European impressionist artists. With his composition combining structural elements from the East and the West art traditions, his style has evolved with techniques similar to Western European expressionism. Just as in his Chinese brush paintings, the subjects in his oil paintings vary: famous historical sites in Europe, street corners, still lifes, human figures, and so on, through which his artistic style converges, blending the natural with the supernatural---creating a vivid visual impact, and leaving the viewers no choice but to be completely amazed and absorbed.

Entering the twenty-first century, Chinese artists are facing a market economy. The temptation of money and reputation diverts many of them from creating serious artwork, and instead, lures some into seeking shortcuts through promotional packaging for quick success. In this hectic market of selling paintings by the foot, Dehui seeks

[1] Freehand ink brushwork of great expression (水墨大写意) refers to a style in traditional Chinese Brush Painting characterized by vivid expression and bold outline.

a hiding place away in his hometown Tian Tai in Zhejiang Province. There he continues to study the important subject of the compatibility of Eastern and Western art forms. The Museum of Tian Tai, appreciating his lifetime dedication to fine art, has set up a permanent exhibition of his work---both Wang Dehui's Chinese Brush Painting and Oil Painting---which is open to the public daily. People of Tian Tai have also built a Wang Dehui Art Studio, providing the artist with a quiet place to think and to create new work. There the artist continues to study the national spirit of Chinese brush painting as well as colour and ink, and at the same time, to experiment with art forms that will embrace the East and the West.

In the summer of 2004, I finally met with Dehui in Beijing after being an admirer of his work for many years. He is slim with a full head of grey hair; he reminded me of an old pine standing against the wind on top of a mountain, or a bunch of long grass growing on the bare rock. This time I had opportunities to enter his artistic world to observe him paint. He sometimes smudged with a dull brush, and sometimes swept with a long stroke, while he outlined a mountain, a river, or drew birds, animals or human figures. With simple brushstrokes, a generous amount of ink and water, a bold application of colours, Dehui paints clouds stretching and folding, birds flying, flowers blooming, fish swimming, and frogs jumping. His work presents the natural with such concentrated colour and energy that sometimes it becomes

supernatural. As he continues to pursue different visual experiences, he magically transforms his subjective and emotional impressions of the objective world through a highly personalized artistic style. This personal style reflects an artist's understanding and realization of the natural world; it shows a mental perspective that is completely subjective, supernatural and spiritual.

This book, *Wang Dehui: Oil and Chinese Brush Paintings* collects a total number of 53 works, including his Chinese brush paintings, Chinese calligraphy, and oil paintings. Its publication by the TSAR Publications in Canada means the work of a contemporary Chinese artist is officially introduced into public library systems in North America, which lack of such books. This collection will help Western readers become more acquainted with the subject of contemporary Chinese art, and therefore provides one more opportunity for artistic exchanges between the East and the West.

In the process of compiling this book and studying Dehui's artistic styles, I have benefited tremendously from his essay, "Inherit the Traditions, Make East and West Art Forms Complementary." I have translated it into English for inclusion in this book so as to share it with the readers throughout the English-speaking world.

Lien Chao, Ph.D
Writer & Critic
Toronto, Canada
Fall 2007

序

從自然到超自然：王德惠的藝術境界

1994年早春，一個偶然的機會，我在多倫多《當代畫廊》看了來自中國杭州的藝術家王德惠先生的《現代水墨畫藝術展》。回憶當時參觀的心情，頗有耳目一新的感受。德惠先生的畫作有着與衆不同的鮮明風格，一次看過，便難以忘懷。他的水墨大寫意，無論是山水，花卉，還是動物，人物，激情橫溢，結構簡潔，綫條粗獷，生動有力，有時僅寥寥幾筆，或色彩絢麗，或水墨交融，給人以豐富的想象力的空間。

從此，我十分關注德惠先生畫作的發展。

1999年，得知畫家受法國"巴黎國際藝術城"的邀請，前往歐洲訪問考察。旅歐半年其間，他背着畫版、畫筆、干糧和水，猶如一個初出茅廬的青年學子，早出晚歸地在街頭作畫，足迹踏遍了法國、意大利、德國、荷蘭、比利時、奧地利和西班牙的國土。在早年習油畫的基礎上，德惠先生反復地錘煉了自己的油畫風格，在幾百幅寫生畫作裏，尋找自己的創作語言。正如他的現代水墨大寫意，他的油畫作品也同樣閃爍着强烈的個性風格，其鮮艷奪目的色彩，戲劇性的構圖，自由奔放的筆路中，似乎還摻插着小孩塗鴉的執着。無論作品的主題是歐洲的名勝古迹，大街小巷，還是人物或靜物，都充滿生命的活力。他大膽用色，尤其是原色，突破歐洲印象派對細膩的追求。他的造型方式則采用東、西匯融，給予表現主義以新意。德惠先生的油畫是對視覺和色彩的挑戰，自由奔放，讓觀衆享受自然和超自然的藝術風格融匯結晶的絢妙。

到了二十一世紀，中國繪畫界進入了商品市場，五花八門的運作和包裝，金錢和名譽的引誘，許多藝術家早已無心創作，求成過急，尋找商業捷徑。在這"論尺賣畫"的喧囂時代，德惠先生却躲進故鄉浙江天臺山裏，繼續研究東、西方藝術互補的大課題。《天臺博物館》設立了王德惠中國畫和油畫的永久展覽室，每天對公衆開放。又承蒙天臺的鄉親們爲他建造了一座《王德惠書畫居》，使得畫家有了一個安靜思考和從事藝術創作的環境。現在，他一方面研究中國水墨畫藝術的民族精神，一方面操筆從事現代中、西互補，彩墨交融的嘗試和實踐。

2004年夏，筆者在北京見到了仰慕已久的德惠先生。他略高而偏瘦的身軀，一頭灰白的頭髮，使我立即想到高山上迎風而立的一株松和貼着岩石頑强生長的一蓬茅草。當我有機會走入他的藝術世界，觀看他作畫時，只見他有時破筆塗抹，有時闊筆橫掃，勾勒山水，塗寫禽獸，描繪人物，他用簡潔概括的筆法，從容瀟灑的墨法，和膽大獨特的色法，畫出雲卷雲舒，鳥兒飛翔，花朵開放，魚游蛙躍。他的藝術境界比千姿萬態的大自然更加集中、更加濃重、更加充滿魅力。他繼續追求視覺感受的突破，表達主觀心靈對事物感知的印迹。通過高度個性化、無規無律的大寫意，來表達自己獨特隱秘的認知。他作品展示的藝術境界是主觀的、超自然的，是精神的。

這本《王德惠畫集》收集了德惠先生的水墨畫、書法和油畫作品共53件，由加拿大《TSAR出版社》出版發行，從而將一位當代中國畫家的作品正式地編入北美各大公共圖書系統，爲彌補西方圖書館缺乏現代和當代中國繪畫書籍的不足，爲西方讀者了解中國現代繪畫藝術，爲促進東、西方藝術交流增加一次機會。

在編輯這本畫册和探索德惠先生畫風的過程中，筆者反復地閱讀德惠先生寫的"繼承傳統，中西互補"的論文，不時地有茅塞頓開的感受。現將其文翻譯成英語一起付印，與世界上更多的讀者研討。

<div align="right">

趙廉, Ph.D

加拿大作家、評論家

加拿大，多倫多

2007年秋

</div>

Life-enhancing Art

This enticing well-chosen representation of Wang Dehui's marvelous calligraphy, Chinese brush painting and oil painting, spanning a decade and a half of his recent work (1990-2005), captures the beauty, vitality and grandeur of the natural and human worlds. His subjects, traditional in Chinese art---birds, animals, flowers, trees. fruit, towering mountains, valleys, bodies of water (river, lake, bay and ocean)---are both representational and symbolic: ideas are translated and themes rendered in a uniquely distinctive convergence of shape, space, and colour.

How can an artist convey to a viewer the idea of long life, for instance? Wang Dehui does it superbly in *Longevity* (1990), a large brush painting (96×175cm) of two small red birds perched on a branch with longer-than-life elegant tails, balancing a great mass of larger-than-real succulent rounded red/yellow peaches. Looking at this work---knowing that peaches will rot, I am aware of sensing/understanding/feeling the <u>idea</u> of longevity in a way I never have experienced before: this moment of <u>seeing</u> becomes longevity. But Wang Dehui's artistry is also expressed in another aesthetic: a combination of Eastern aesthetic tradition and subjects with modern Western techniques. The *Festival of Splashing Water* (1993), depicting a ritual of celebration---bare feet women dancing and making music (detail on cover) may be seen as a transition to his later paintings---oils reflecting the influence of the French impressionists in both subject and technique: *A Lady in a Pink Summer Dress* (1999), *A Lily Pond in Paris* (1999), *Nude Woman Lying on Her Side* (2002), *Sunset on the Desert* (2005)---all are works more "Western" in subject and character: a woman in repose on a chaise longue in a lush green garden; vivid colours---reds, flesh-tones for a woman's nude figure outlined in green.

Although Wang Dehui's work is confined here to pages between covers, how stunning they would be on walls! Whatever the format, if attentively "read," his paintings are exhilarating, life-enhancing---a transcendence to a spiritual reality.

Virginia J. Rock, Ph.D, D. Litt.
Professor Emeritus
York University
Toronto, Canada
Fall 2007

强化生活的藝術

這本引人注目的畫册精選了王德惠從1990到2005近十五年來的優秀的書法、中國畫和油畫作品。主題來自傳統的中國藝術,有鳥類、動物、花卉、樹木、水果、山峰、峽穀、河流、湖泊和海洋。作品既有物象又有象征性,思想和主題以獨特的藝術方式體現在形體、空間、和顏色之中,充分地表現出人類和自然世界的美感、活力、和博大的藝術魅力。

一個藝術家是怎樣把長壽的意思傳達給觀衆呢? 王德惠在《多壽圖》這張大幅作品裏成功地用停在樹枝上的兩只美麗的紅色小鳥的長尾羽翼, 和豐腴無比、紅黃相間的、透熟的水蜜桃來表達這個意境。看着這幅作品, 我想明知蜜桃會腐爛, 但我却感受并理解到從未有過的對長壽意境的感悟: 此時此刻, 我欣賞這幅作品的時刻就變爲長壽了。然而, 王德惠的藝術也表現出另一種美感: 東方的美學傳統和主題融合到西方的技巧裏。《潑水節》描述了一個傳統民間慶祝活動: 赤着脚的年輕婦女們歡樂地跳着唱着; 這張水墨畫作品或許和他后來那些受法國印象派主題和技巧影響的油畫作品之間有着密切的關系。《穿粉紅色連衣裙的女人》、《巴黎睡蓮池》、《側睡女人體》 、《大漠日落》,等作品可以説從主題到特征都更加"西化"一些; 坐在活動睡椅上的女子身后是綠茵綠茵的花園; 另一幅大紅和翠緑生動地襯托着一個女子裸體。

王德惠的作品雖然禁錮在畫册裏, 如果挂在墙上又將是何等的魅力! 然而, 無論以什么形式來仔細地品味他的作品, 都令人無比興奮, 强化生活, 升華人們的精神境界。

弗吉尼亞·洛克博士, 榮譽博士
約克大學榮譽教授
加拿大多倫多
2007年秋

譯文: 趙廉博士

Inherit the Traditions and
Make East/West Art Forms Complementary

An Essay by the Artist

Artists are obsessed with painting their own feelings about the objective world. While feeling itself belongs to the spectrum of abstract thinking, each painting reflects the artist's impression of life. As a creative artist working with painting brushes, I am engaged in both Chinese brush painting and oil painting. In spite of their different origins, they represent two peaks in the world of fine art. Emotionally, I am attached to both.

While studying the artistic forms of traditional Chinese Brush Painting, Chinese artists also need to absorb the essence of Western Oil Painting. If they make efforts to study the traditions and origins of both art forms, they will benefit from having a profound foundation to establish their own personal version of a national art form.

Chinese Brush Painting has a history of over one thousand years; its philosophy and techniques accumulated throughout history have formed the essence of this national art form. Different from oil painting, Chinese brush painting employs a line-based approach to composition. Natural colour is less important, and instead, a subjective representation of colour is applied. The artists also adopt a "horizontal and dimensional approach" to deal with time and space. They can move the focusing perspective up and down, left and right. In terms of observing the natural world, it is not expected to sketch the objects at hand. Sketching can be done sometimes by looking at the object and memorizing it. Blank space is also important in a Chinese brush painting as it complements the painted area.

Ideally, the artists look not only for "similarity in form," but more importantly, "similarity in spirit"; they demonstrate both "brush techniques" and "ink techniques," finally aiming to achieve the fullest effect in a painting---"animating spirit and vitality" (气韵生动).

Artistic creation echoes the time. Today rapid developments in science and technology have changed artistic trends and concepts of beauty. Contemporary Chinese brush painting should inherit its own tradition, absorb Chinese calligraphy, and learn from various western art schools. It should be an art form that combines scientific and artistic approaches to life and therefore, it should embody various cultural influences. Art connects, but it cannot become the same as something else. An artwork can only achieve the status of becoming more connected to the objective world, or much like, but it cannot become much the same. If the latter happens, then it is no art. What it means is that the creative spirit of an artist has to be absolutely free in order to let consciousness and sub-consciousness function in the creative process. The sayings that "masters leave marks of awkwardness" or "words cannot express meaning" illustrate something of the aesthetic standards of Chinese brush painting.

As art is creation, concepts and techniques are two important factors. Artistic thinking often surpasses common sense. What an artist sees sometimes challenges what ordinary people view as real, true or beautiful. Artistic creation demands enormous efforts. Every painting absorbs the author's thoughts, feelings and spiritual strength. By altering shapes and colours, artists reflect different essences and traits in each painting. For example, in traditional Chinese brush paintings, artists sometimes paint an orchard with black ink but bamboo in red colour. The sun is usually represented by a circle, but in a painting, an artist might add some angles to the sun to make it more amusing, interesting, humorous, or simply funnier.

In the recent decades, as a result of frequent exchanges between China and the West, many changes have happened in traditional Chinese brush painting and modern ink painting. Apart from following certain rules of brush and ink, Chinese artists began to emphasize emotional and spiritual qualities and subjective concepts as parts of the aesthetic unity and artistic form. Nowadays almost every Chinese artist is searching for his or her own artistic form and expression. Many paintings demonstrate changes in traditional patterns, and the emphasis has shifted from valuing the subjects over to the subjectivity. As Chinese artists began to pursue the internal structure of art, they started to establish a distance between contemporary ink painting and traditional Chinese brush painting by taking new, multi-directional approaches to their national art form.

I studied oil painting initially in the 1950s; however, my love for this Western art form rekindled more seriously at the end of the twentieth century when I spent half a year at the residency of the "International Art City" in Paris. During this time, I visited the museums and art galleries in Europe, and sketched wherever I had been. As I was overwhelmed by the striking power of oil painting, it became another favorite art medium for me. This undertaking has brought me another splendid artistic world; as a result, I have a new opportunity to make Eastern and Western art meet in a complementary way in my own work.

While pondering the transformation of tradition, and rethinking Chinese brush painting, I am constantly searching for new expressions. "A single flower is a world," an old saying goes; I want to paint what I think. This may still be a beautiful dream though; to realize it requires an arduous long journey.

Wang Dehui
Summer 2007
Tian Tai, Zhejiang, China

Translated by Lien Chao, Ph.D
Fall 2007
Toronto, Canada

藝術家的話

繼承傳統，中西互補

藝術家想畫自己對客觀事物的感受。感受雖然純屬抽象思維的範疇，每一幅畫却能反映出藝術家對生活的印象。從事筆耕爲業的我，國畫、油畫都畫，對中西繪畫有所愛，也有所感。這兩個畫種雖不同源，却同是藝術世界裏的兩座高峰。

在學習研究中國民族形式繪畫優良傳統的同時，一個中國畫家還應該注意吸收西方繪畫藝術的精華，努力做到兼收并蓄，融會中西，尋流溯源，建立具備民族繪畫形式的個人畫法和風格。

中國繪畫千余年積纍的創作方法和創作思想是構成國畫民族形式特點的主導方面。和西方油畫不同的是中國繪畫以綫爲主造型，對物象的固有色，以主觀的理想表現，畫家以"散點透視"營構方式，突破時空限制，視點可以按一定的規律上下或左右移動。中國繪畫觀察自然，不純粹對景寫生，講究目寫、心寫和手寫。在畫面上，中國畫以虛帶實，虛實相生。一幅理想的國畫不但要求"形似"，更要求"神似"，要求有筆法、墨法、最后達到"氣韵生動"，應該説是最高境界。

藝術創作當隨時代。現代科學技術的迅速發展改變了文藝思潮和審美觀念。中國現代水墨畫藝術應該繼承民族書畫的傳統，同時要向西方繪畫各個流派學習和借鑒，追求科學美和藝術美的相互結合、相互滲透的抽象美。藝術只能通，不能同，只能大通而不能大同，大同則無藝術。這就是强調畫家的主體精神絕對自由，以及無意識、潛意識在創作中的作用，并確立"大巧若拙"，"言不盡意"的美學標准。

藝術是一種創造，觀點和技巧是繪畫的重要問題。藝術家常用超越常人的思維方式，他看到的事物并不是正常人可以看到和理解的一種真善美的創新。藝術創作必須付出極大的勞動。每幅繪畫作品會融入作者的思想感受、情緒，和自我的心靈力量，抒發内在的品格與氣質。通過變形、變色等手段反映不同的事物本質與内在特征。如傳統畫中的"墨蘭"、"朱竹"，再如幾何圖形上的太陽是圓的，但是到了畫家筆下可能有了棱角。這樣讓人看了有興趣、理趣、諧趣、妙趣。

近年來，現代水墨畫與傳統國畫在各個方面都發生了極大的變化，主要是在東方與西方藝術交匯中得到啓迪與影響。除了遵守筆墨規範之外，在審美主體和繪畫形式上强調表現心靈情感和主觀意念，幾乎每個畫家都在探索自身繪畫表現形式與藝術語言。許多畫面改變了傳統套路，由重視題材的價值轉換爲表現主觀價值。中國藝術家開始追求藝術的内在結構，他們使現代水墨畫與傳統國畫拉開距離，向多元化方向發展。

五十年代我初習油畫，在二十世紀末年，我對西洋油畫的愛好再次突起。在巴黎國際藝術城的半年訪問期間，我參觀了歐洲各大博物館和藝術館，所到之處隨時隨地寫生。油畫的衝擊力吸引着我，其絢麗之極的色彩給我留下極爲强烈的感受。今天，油畫也是我最喜愛的畫種，我多了一個別有洞天的藝術世界，在我的畫中也多了一個嘗試中西繪畫互補的機會。

反思傳統，變异思遷，在中西繪畫藝海中尋找創意，在借鑒西方繪畫中再認識中國畫。"一花一世界"怎樣想就怎樣畫，是一個美好的理想，要做到也苦也難。

王德惠
2007年夏
浙江天臺

Plates

圖　版

中國畫
Chinese Brush Painting

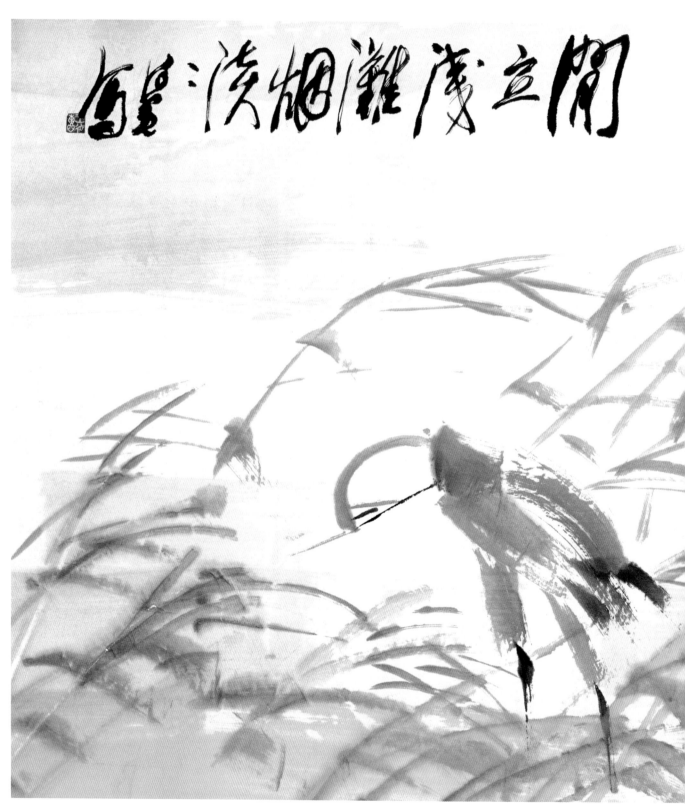

Hidden in the Reeds (1994)
蘆葦叢中
177×358 cm; 69.7×141 inch.

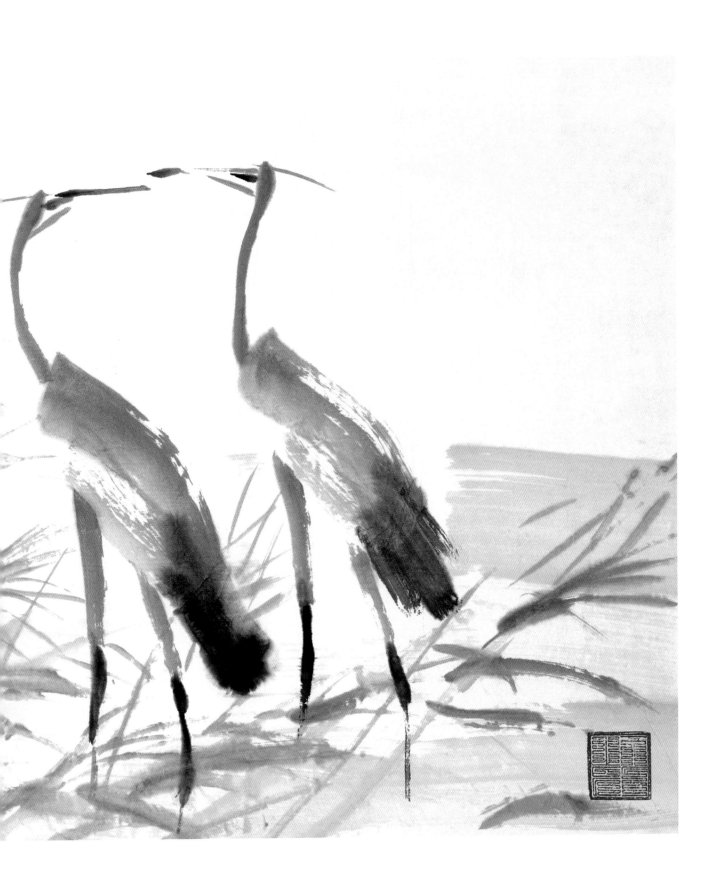

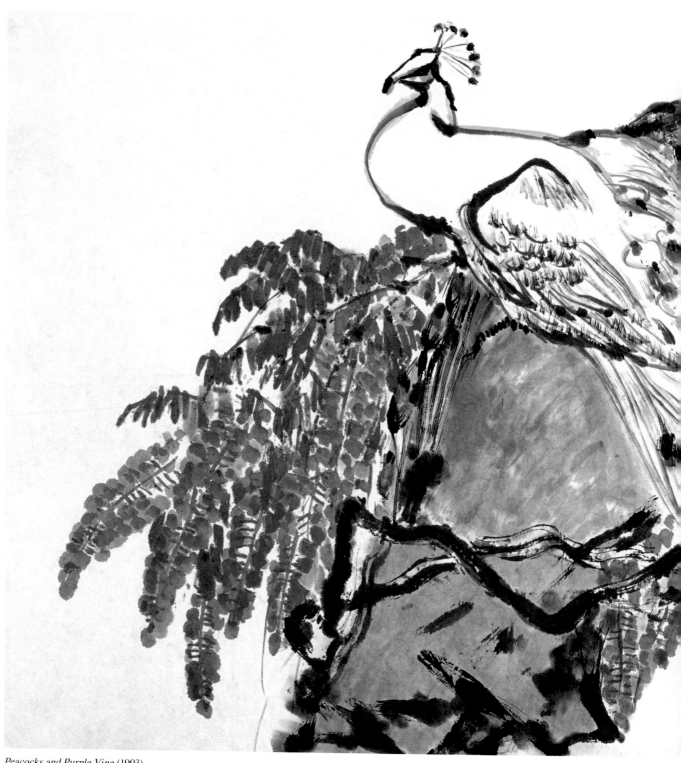

Peacocks and Purple Vine (1993)
孔雀紫藤
68×136 cm; 26.8×53.5 inch.

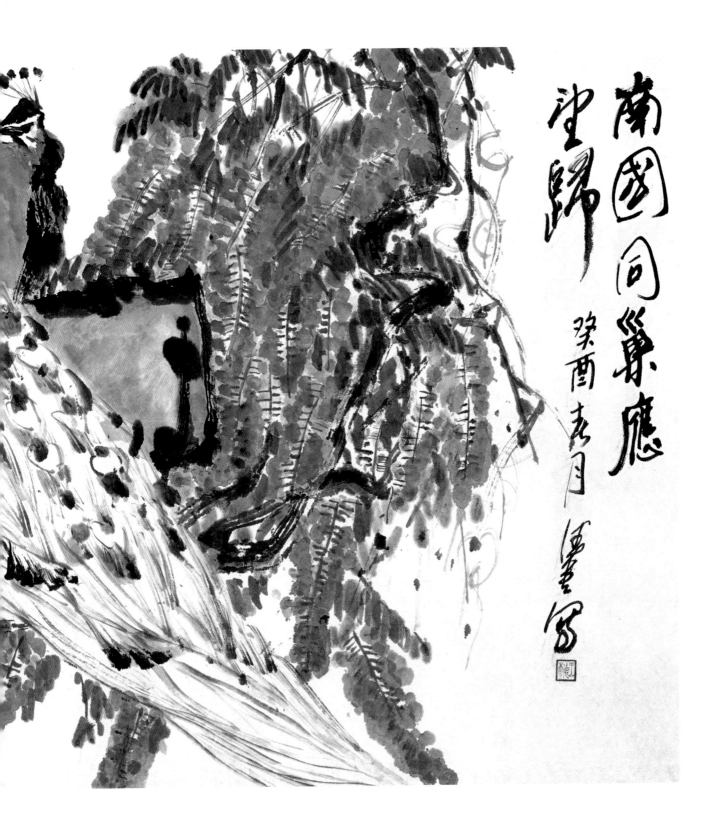

南國同巢鷹望歸

癸酉春月 漢寫

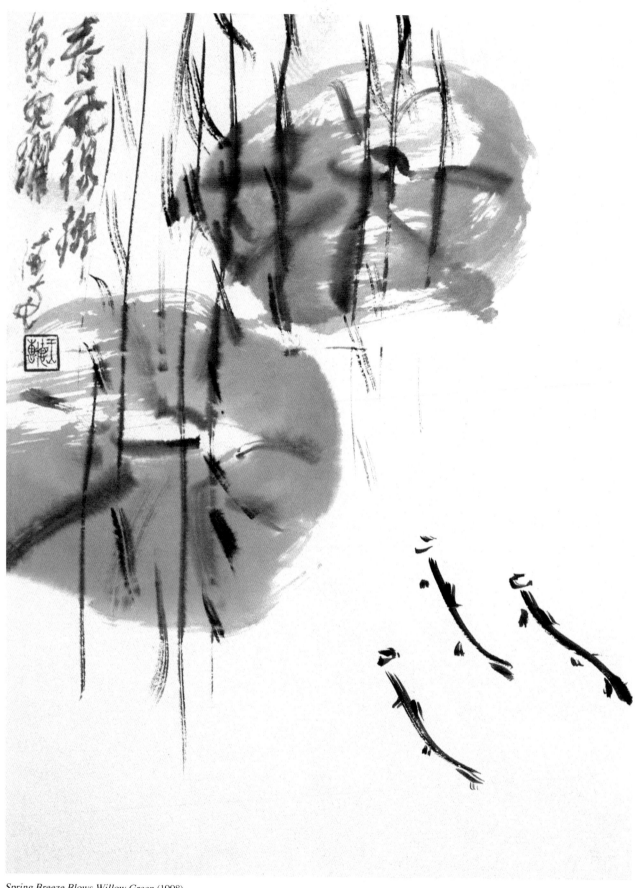

Spring Breeze Blows Willow Green (1998)
春風楊柳
46×34 cm; 18.1×13.4 inch.

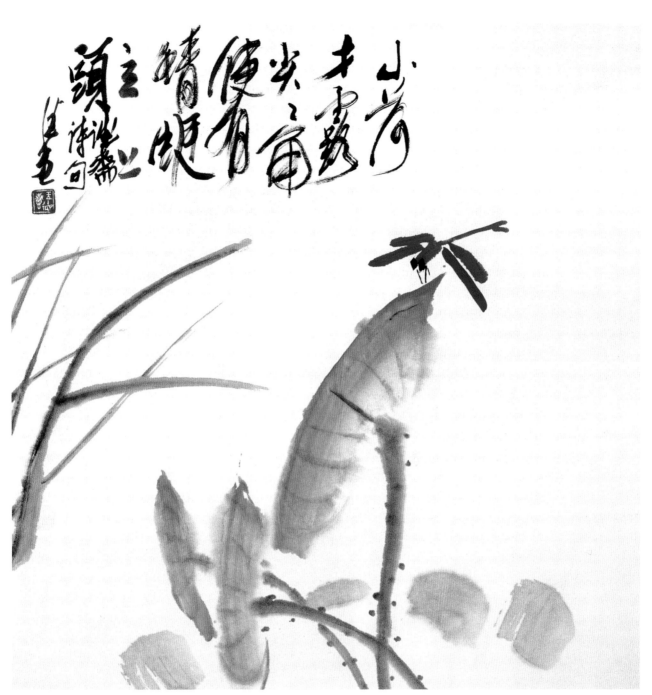

Young Lotus Shooting Up (1994)
小荷與紅蜻蜓
68×68 cm; 26.8×26.8 inch.

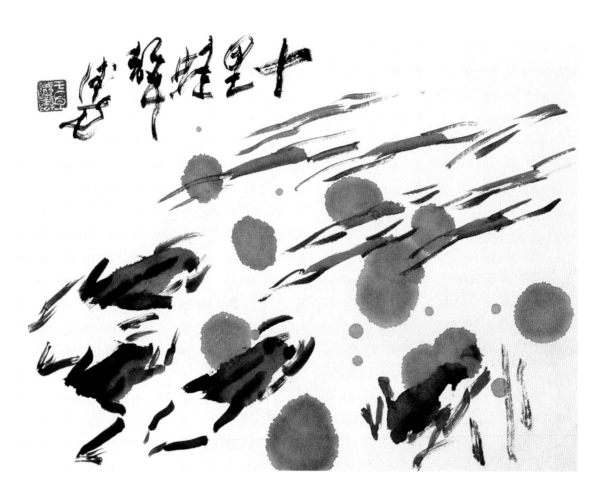

十里蛙聲

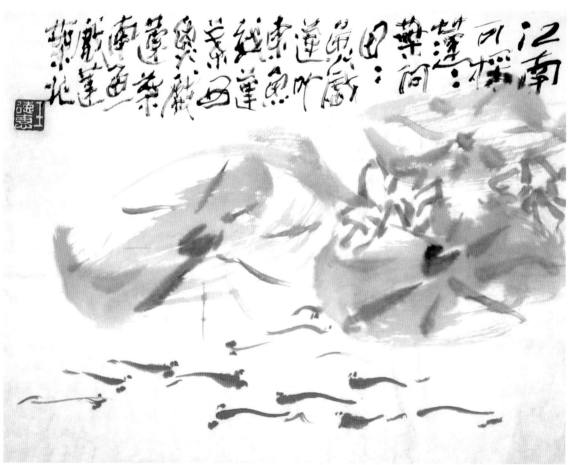

江南可採蓮，蓮葉何田田，魚戲蓮葉間，魚戲蓮葉東，魚戲蓮葉西，魚戲蓮葉南，魚戲蓮葉北。

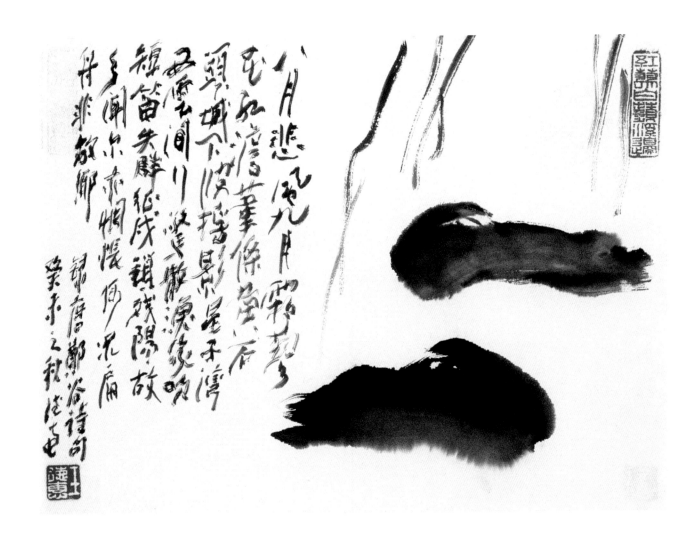

Top left: Frogs Crying Ten Miles Long (1995)
左上：十裏蛙聲
34×46 cm; 13.4×18.1 inch.

Bottom Left: Under the Lotus Leaves (1995)
左下：江南荷葉
34×46 cm; 13.4×18.1 inch.

Right: Chilly Late Autumn (2003)
右：八月悲風九月霜
34×46 cm; 13.4×18.1 inch.

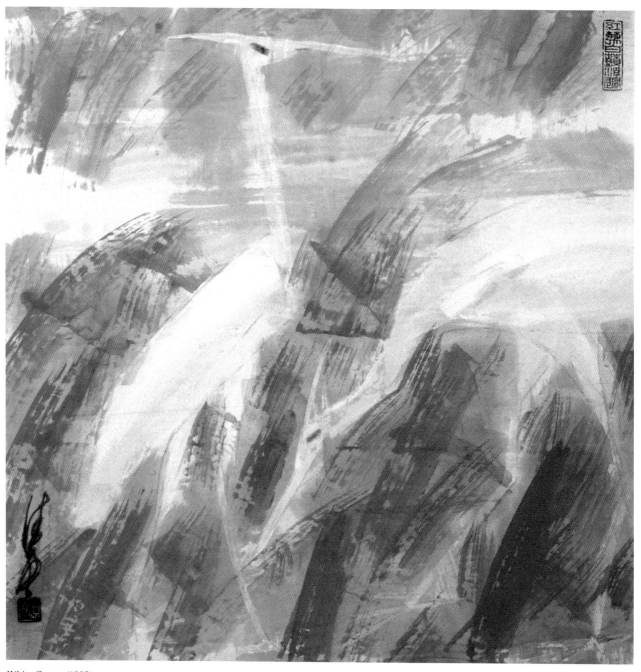

White Cranes (1992)
白鶴
68×68 cm; 26.8×26.8 inch.

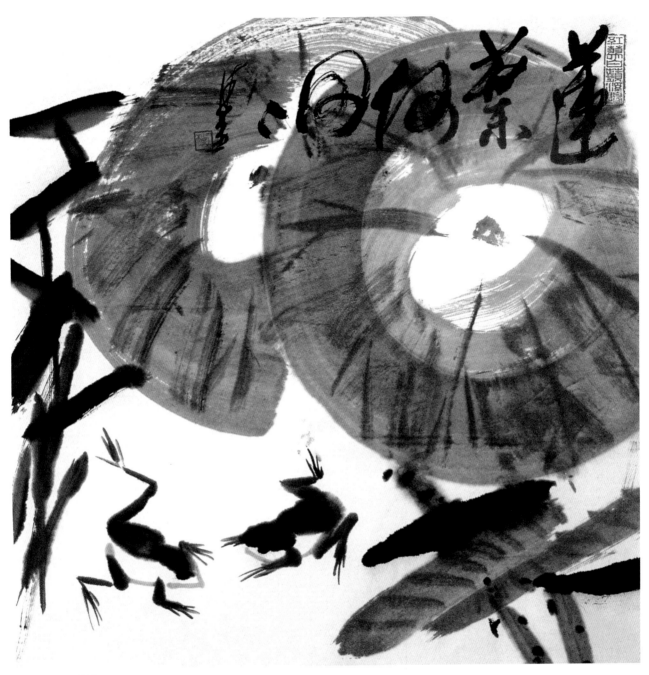

Lotus Leaves (1994)
蓮葉荷田
68×68 cm; 26.8×26.8 inch.

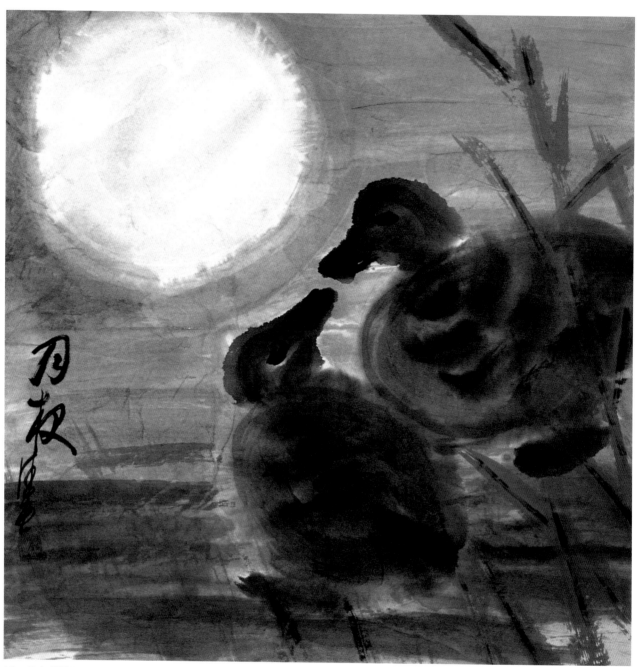

Moonlight (1994)
月夜
68×68 cm; 26.8×26.8 inch.

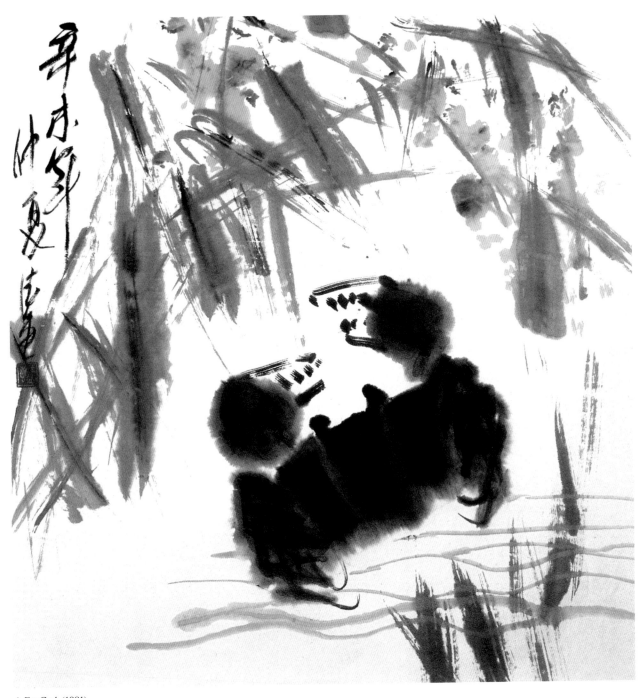

A Fat Crab (1991)
肥蟹
68×68 cm; 26.8×26.8 inch.

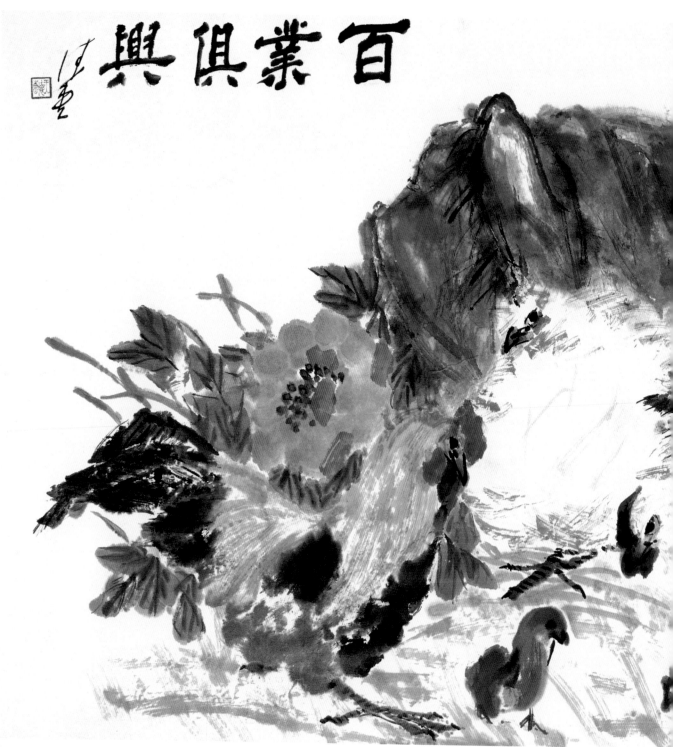

Prosperity (1993)
百業俱興
136×68 cm; 53.5×26.8 inch.

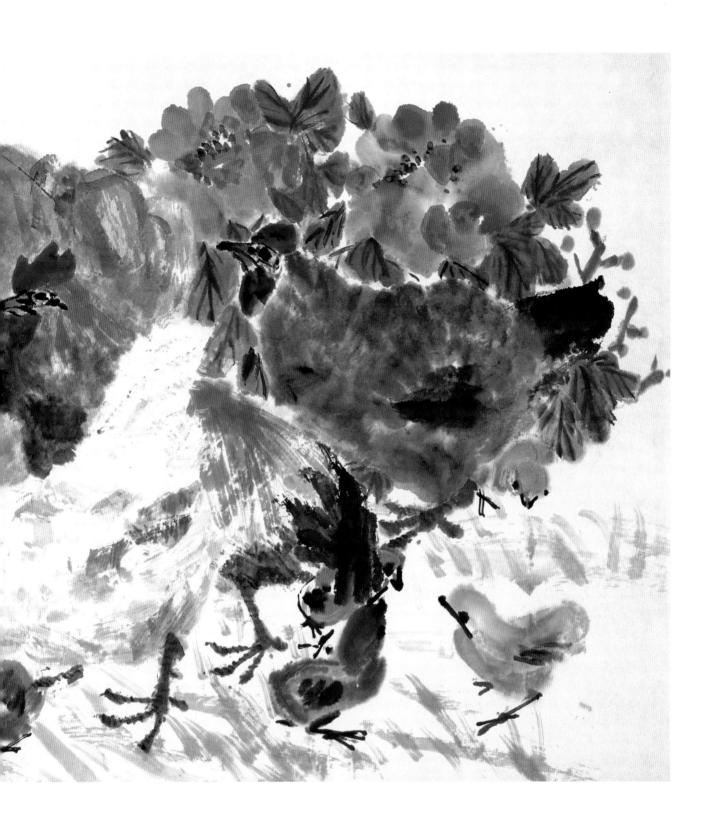

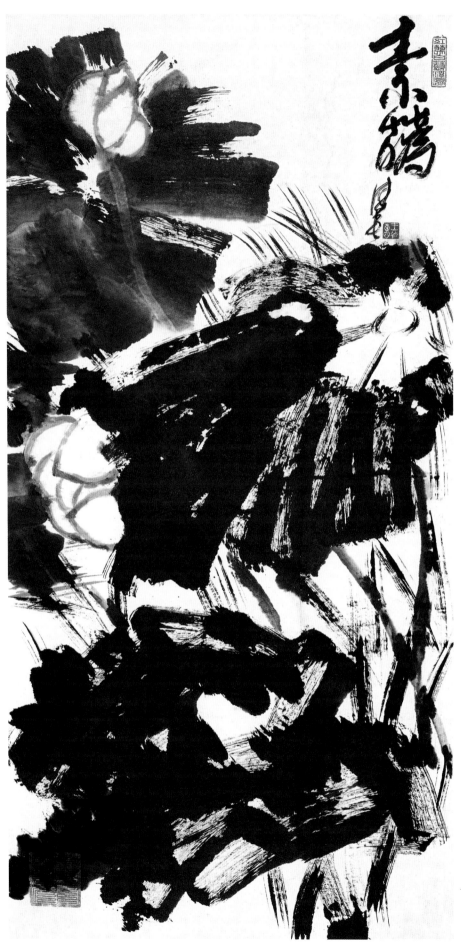

Ink Lotus (1993)
墨荷
136×68 cm; 53.5×26.8 inch.

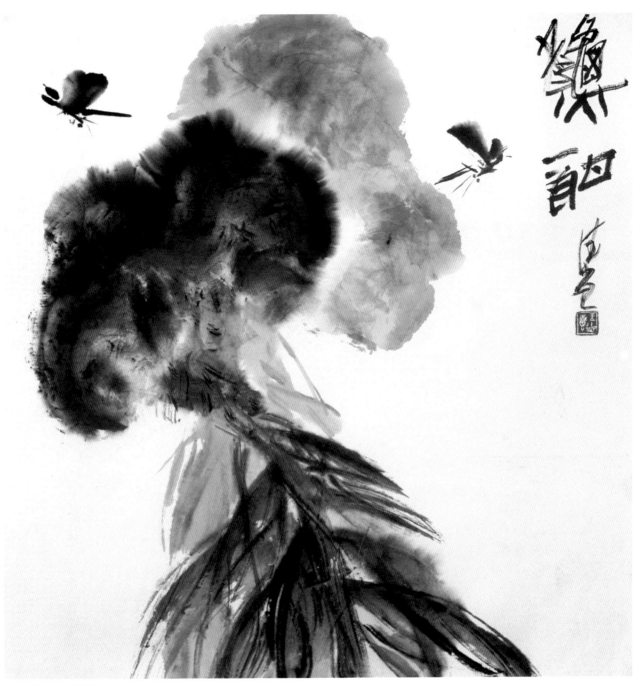

Deep Autumn (1994)
秋酣
68×68 cm; 26.8×26.8 inch.

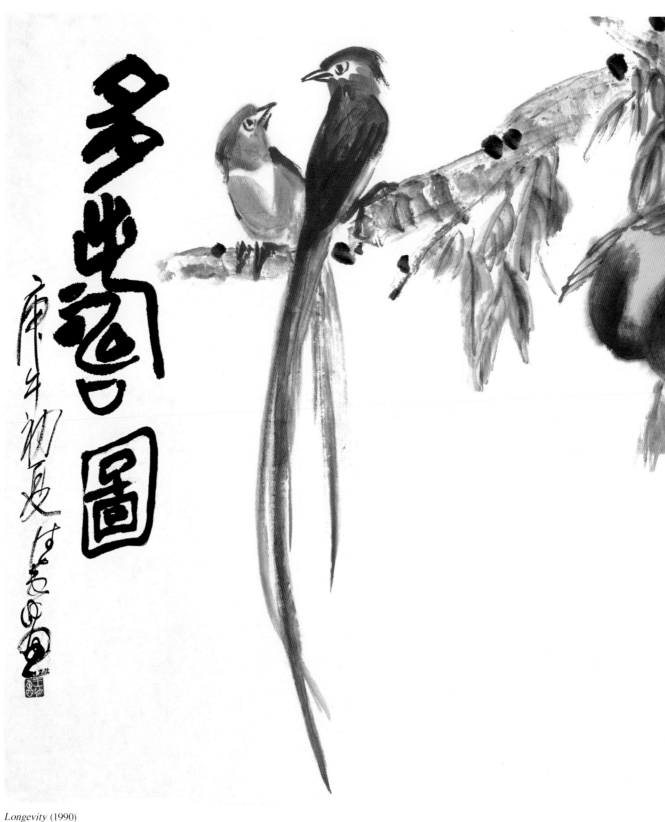

Longevity (1990)
多壽圖
96×175 cm; 37.8×68.9 inch.

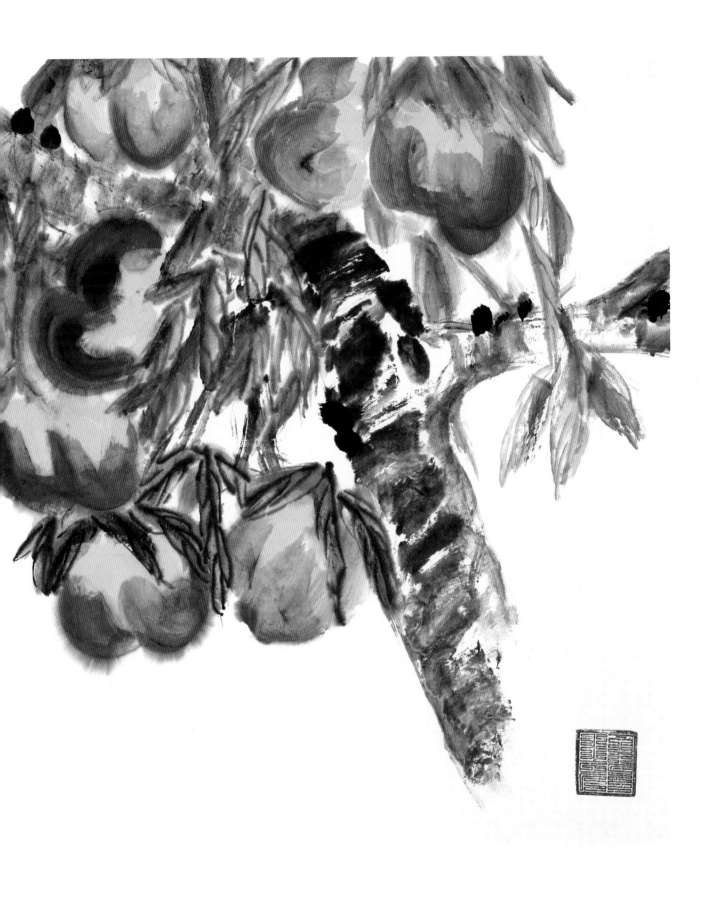

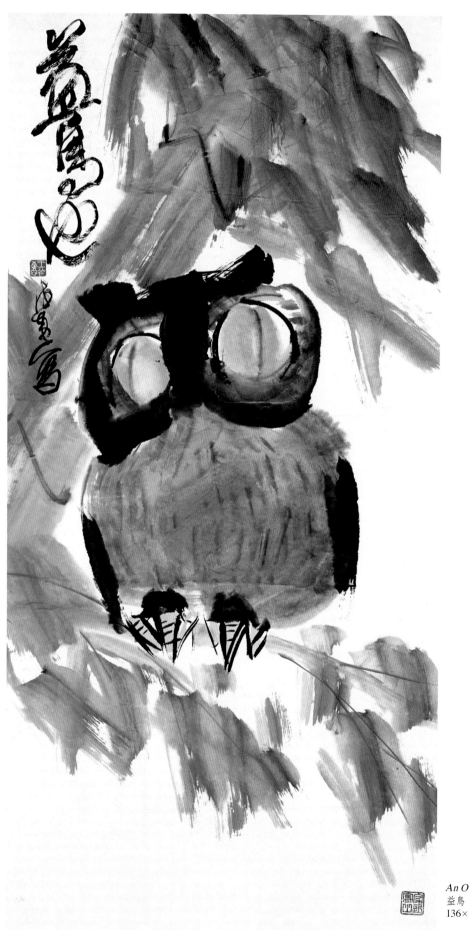

An Owl (1996)
益鳥
136×68 cm; 53.5×26.8 inch.

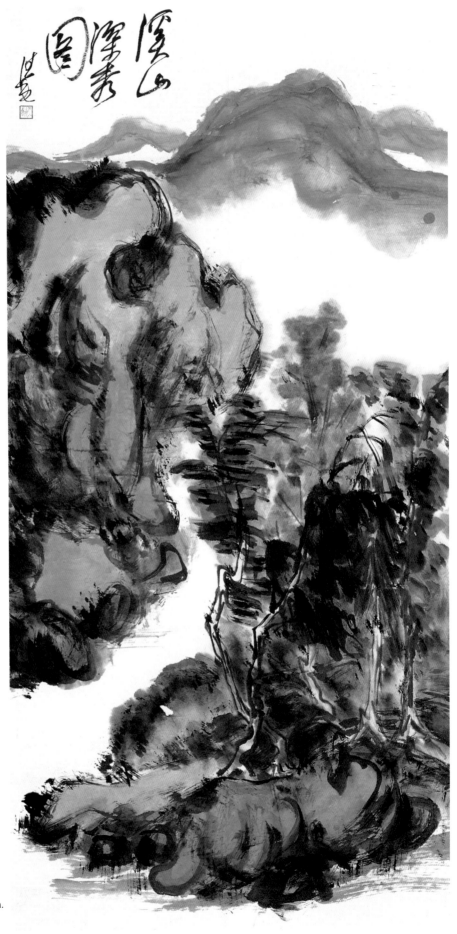

Mt. Xi Beauty (1993)
溪山
136×68 cm; 53.5×26.8 inch.

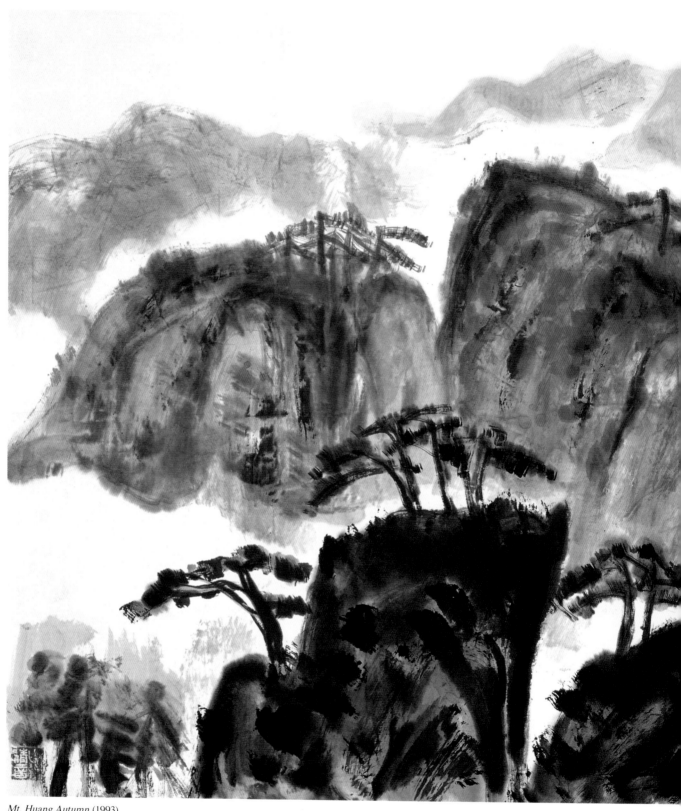

Mt. Huang Autumn (1993)
黄山之秋
96×175 cm; 37.8×68.9 inch.

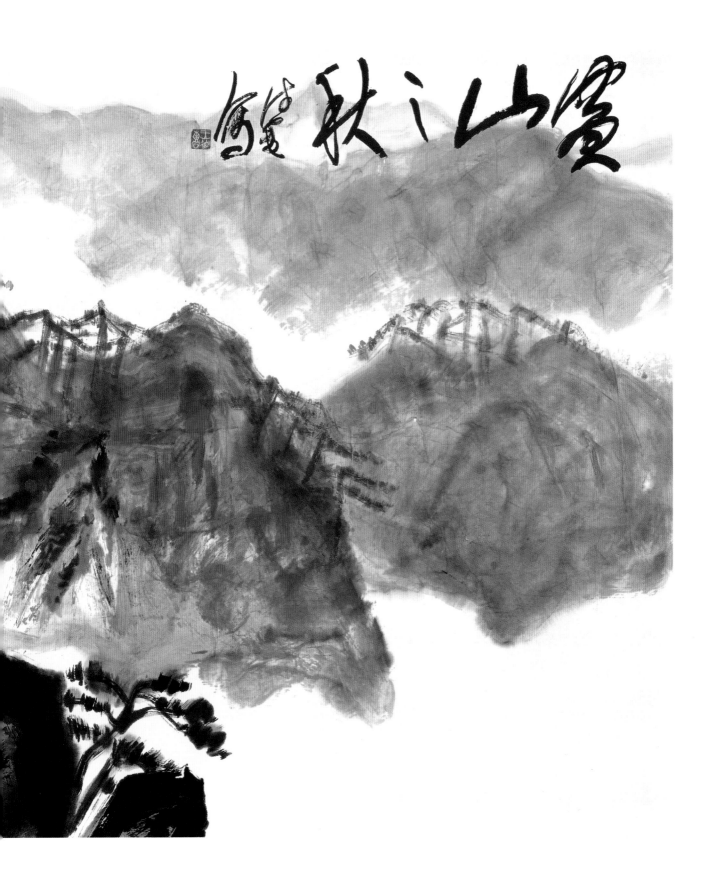

秋江山色

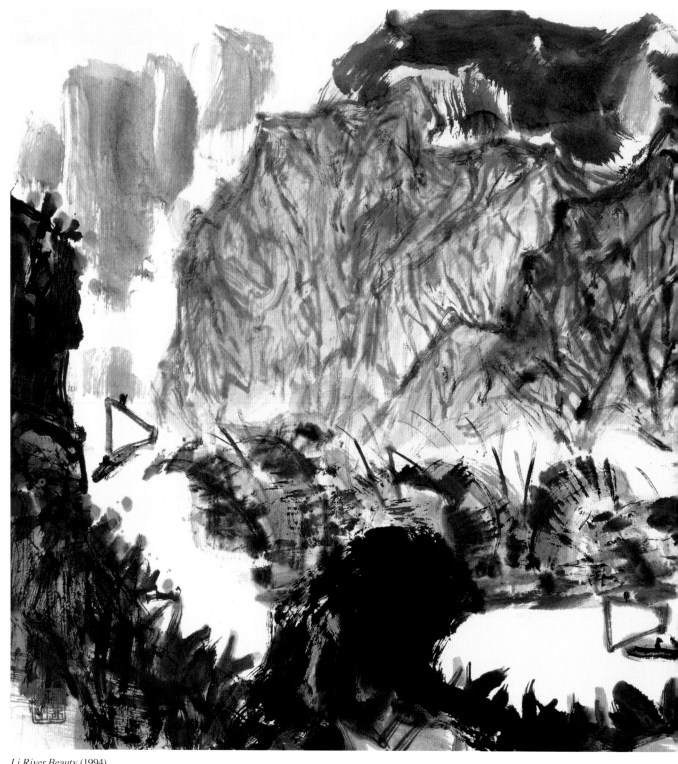

Li River Beauty (1994)

清灘奇秀

70×140 cm; 27.6×55.1 inch.

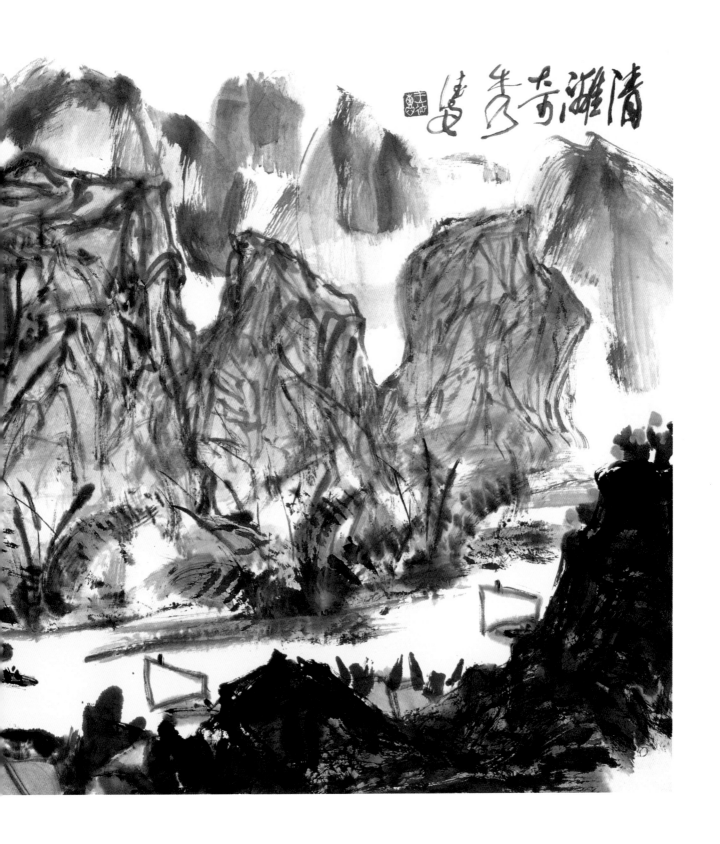

清漓奇秀

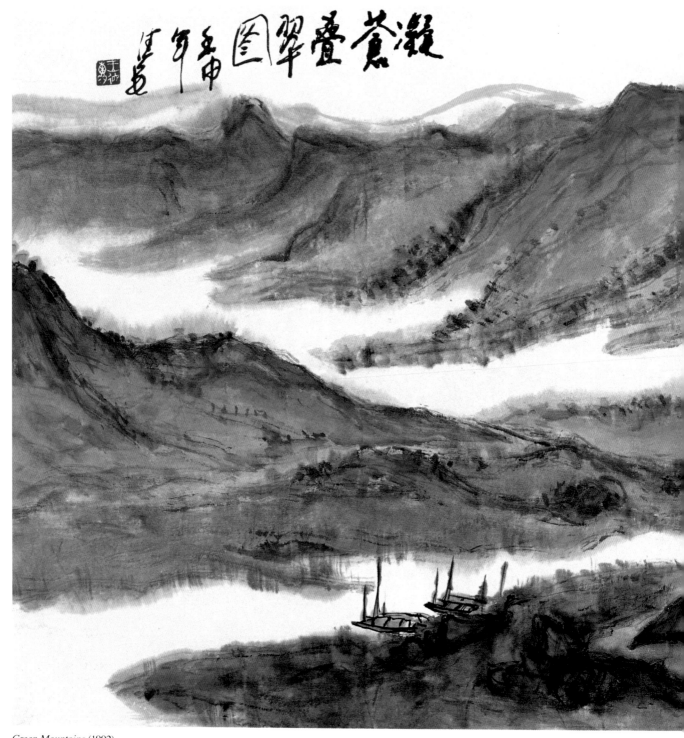

Green Mountains (1992)
凝蒼疊翠圖
136×68 cm; 53.5×26.8 inch.

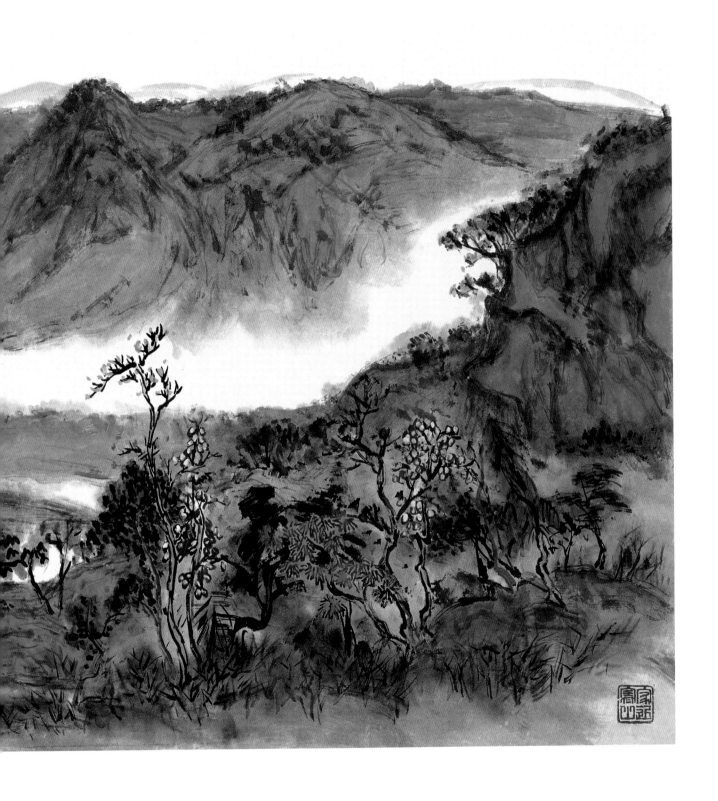

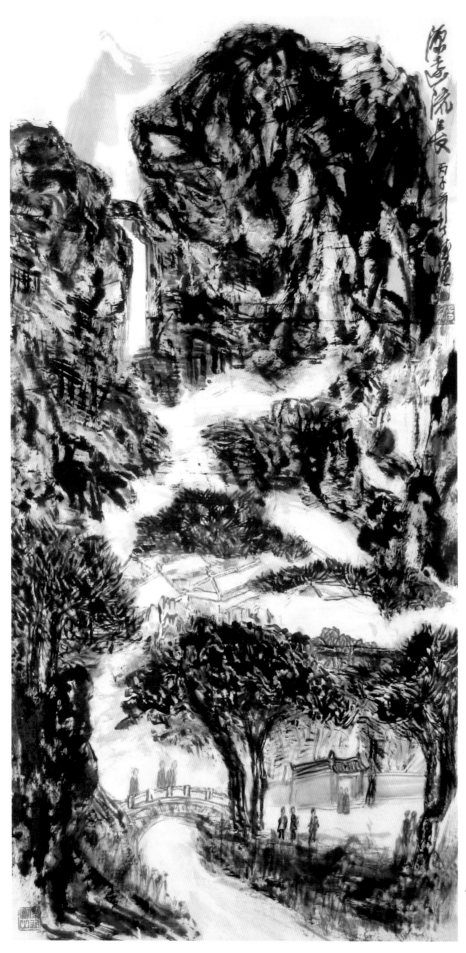

Mt. Tian Tai Guo Qing Temple (1996)
天臺山國清寺
136×68 cm; 53.5×26.8 inch.

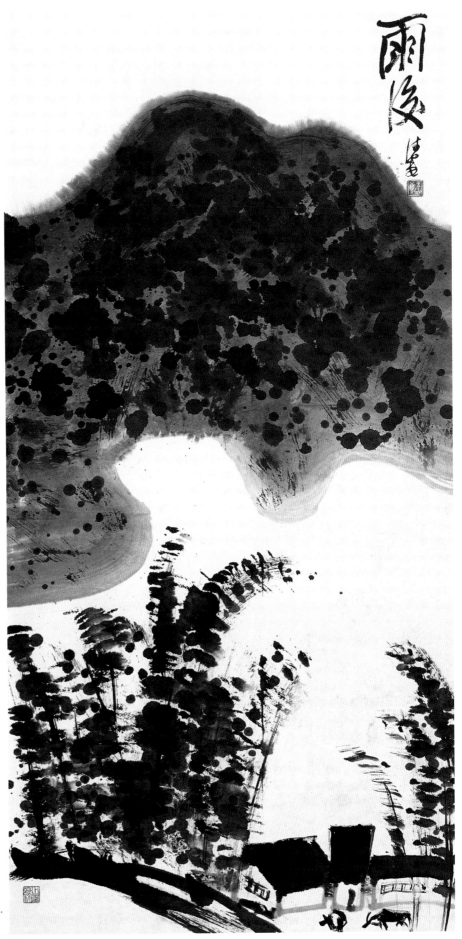

After the Rain (1994)
雨后
136×68 cm; 53.5×26.8 inch.

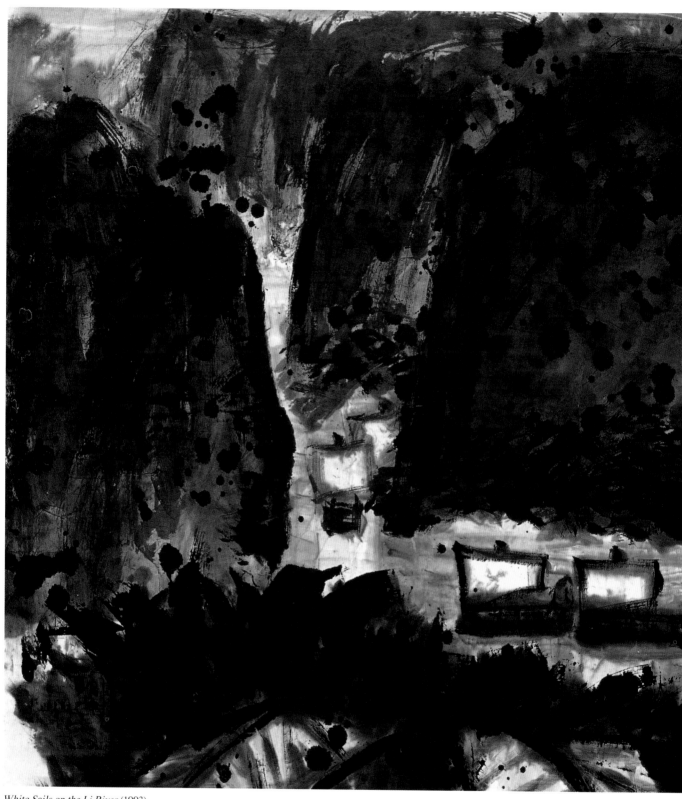

White Sails on the Li River (1993)
灕江帆影
94×173 cm; 37×68.1 inch.

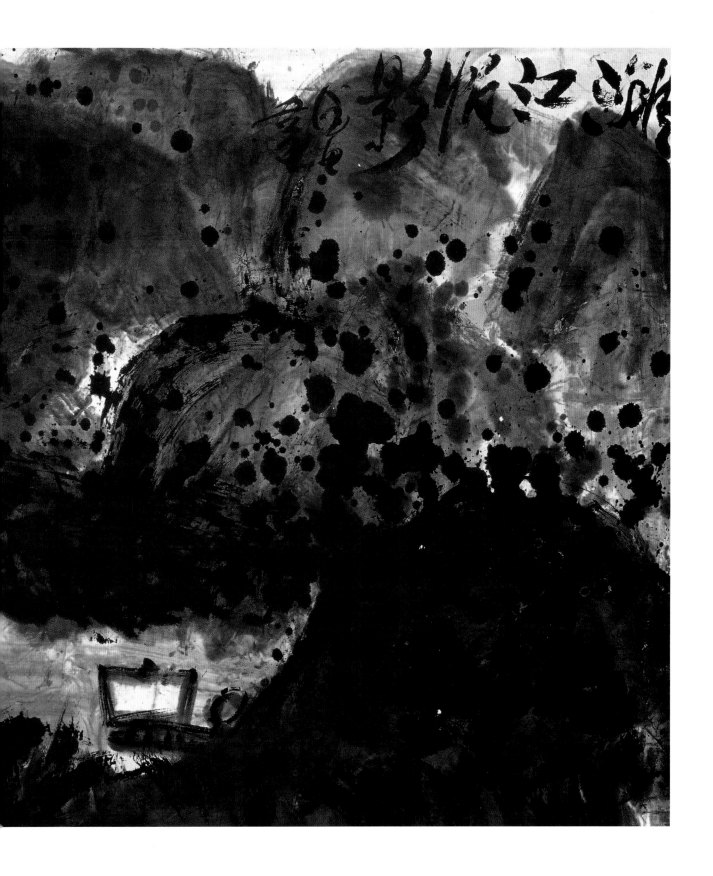

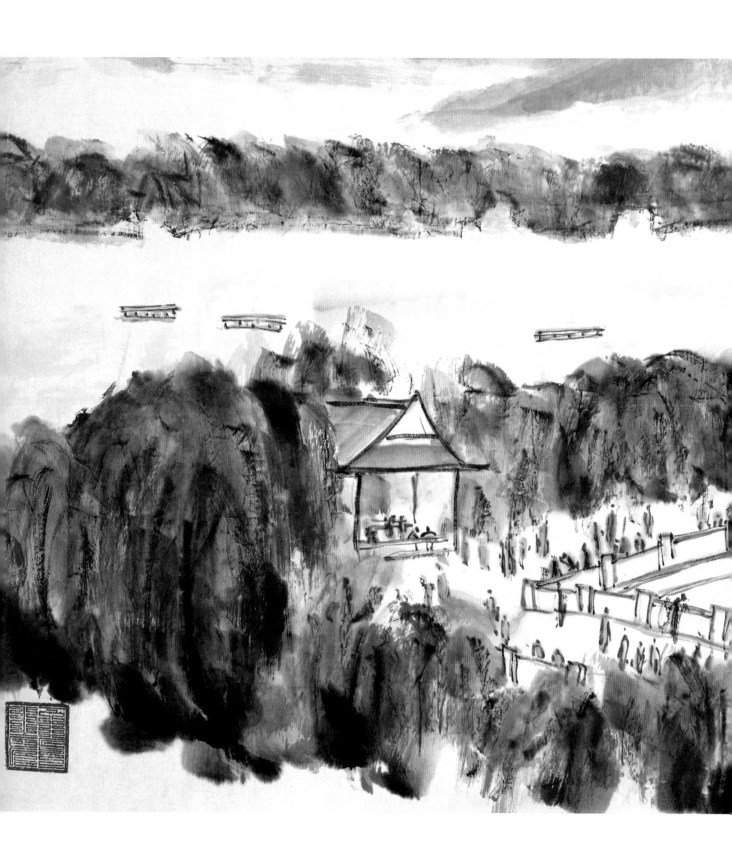

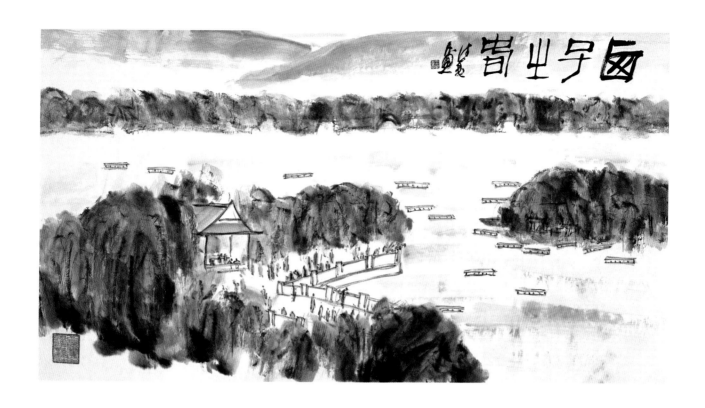

Spring on the West Lake (1993)
西子之春
94×170 cm; 37×66.9 inch.

Left: Detail
左: 局部

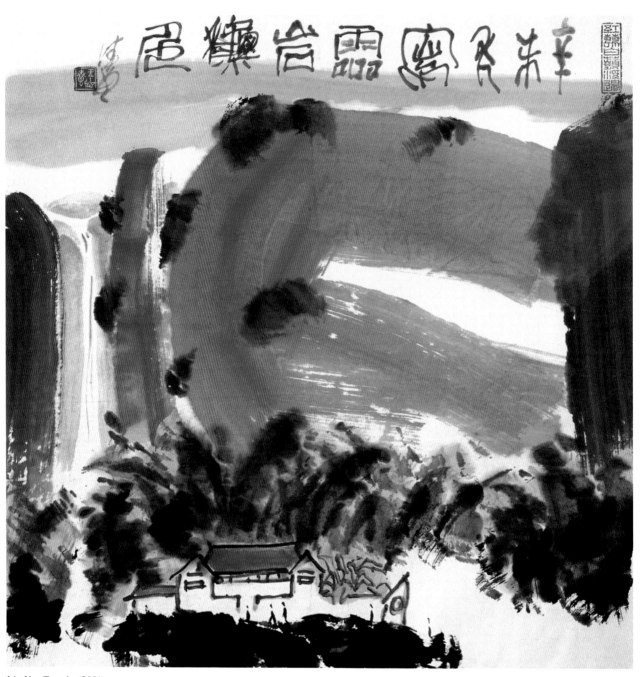

Lin Yan Temple (2001)
靈岩寺
68×68 cm; 26.8×26.8 inch.

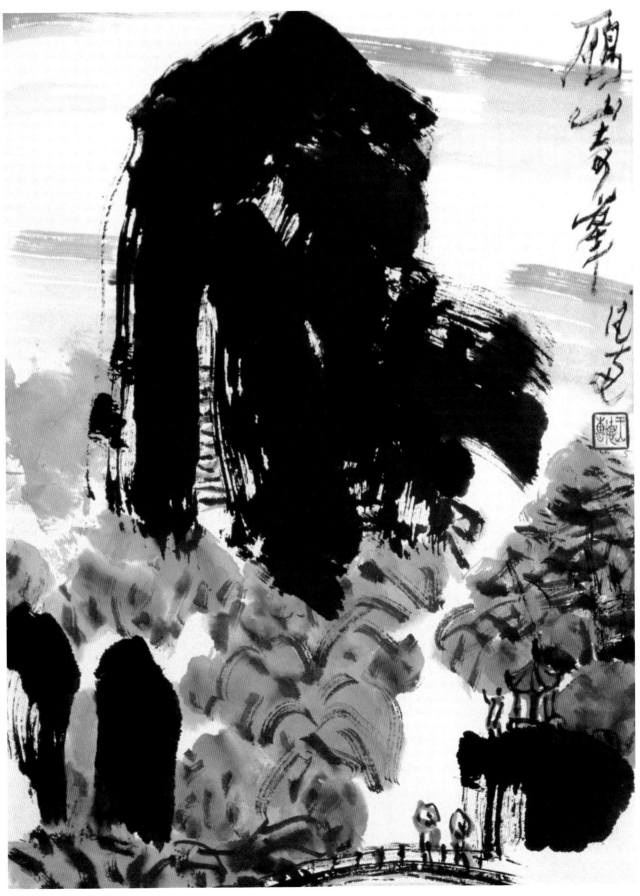

Mt. Yan Peak (2005)
雁山奇峰
46×34 cm; 18.1×13.4 inch.

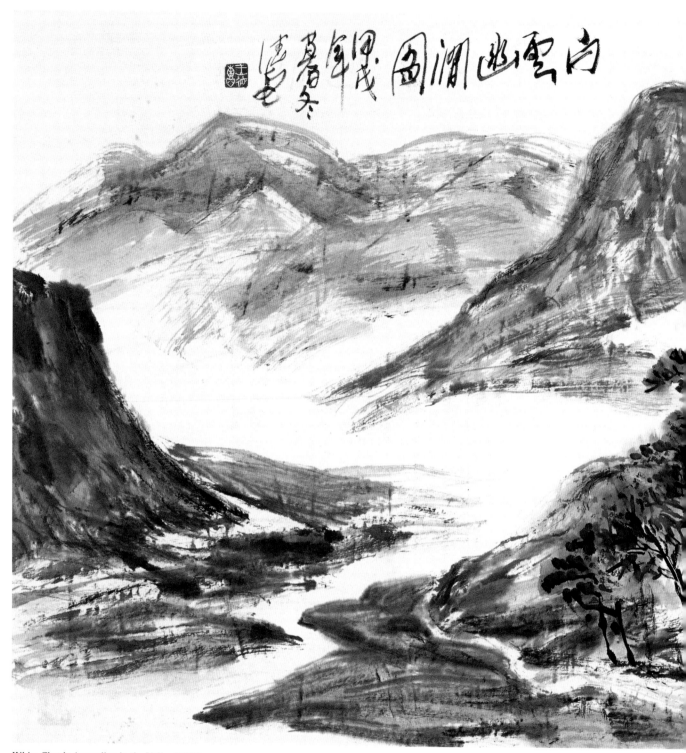

White Clouds Ascending in the Valley (1994)
白雲幽澗
70×140 cm; 27.6×55.1 inch.

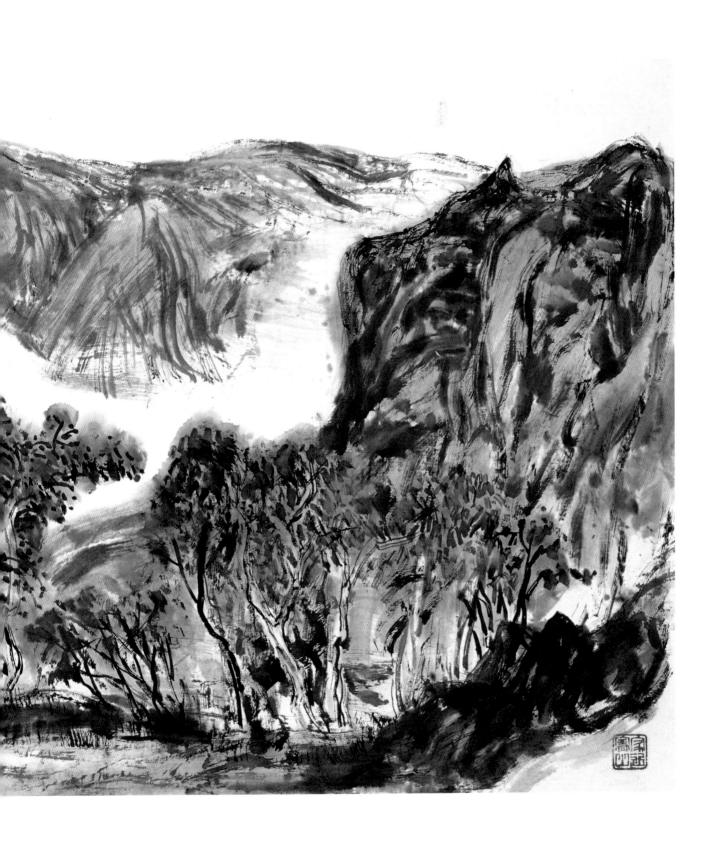

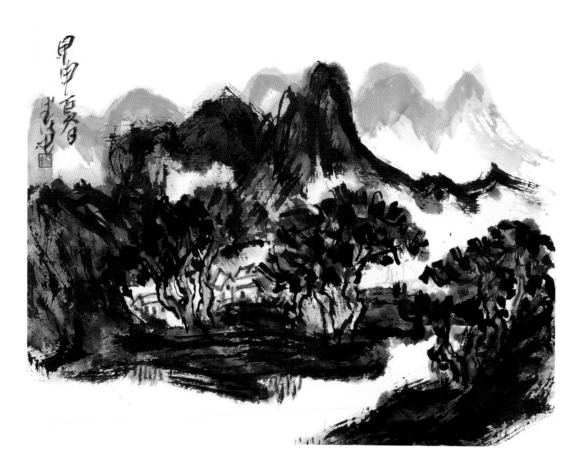

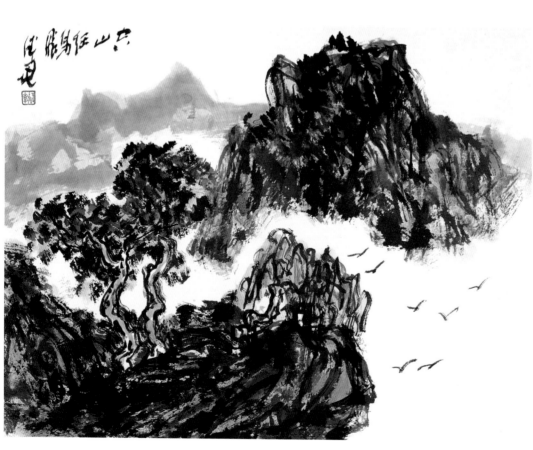

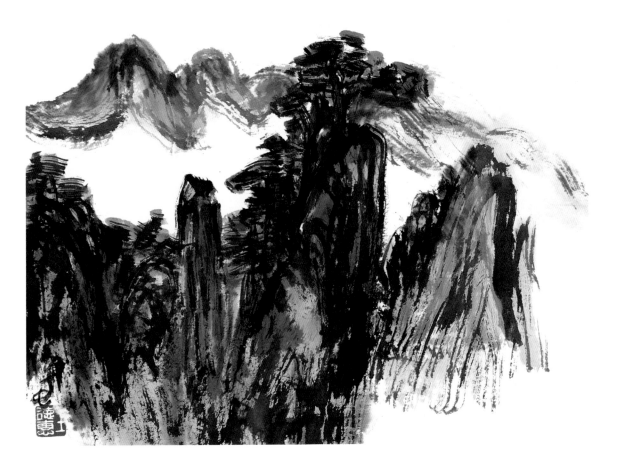

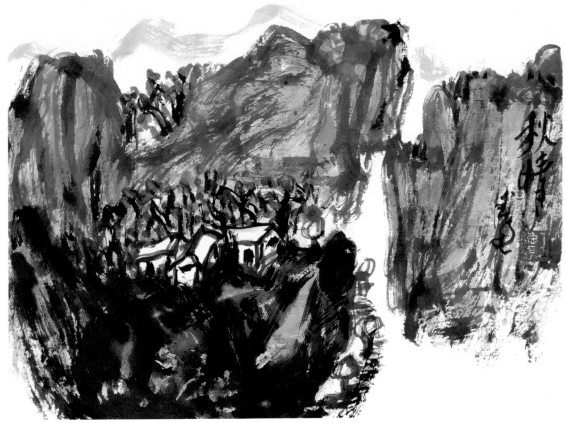

Four Pages of Landscapes (2004)
山水冊頁四幅
35×45 cm; 13.8×17.7 inch.

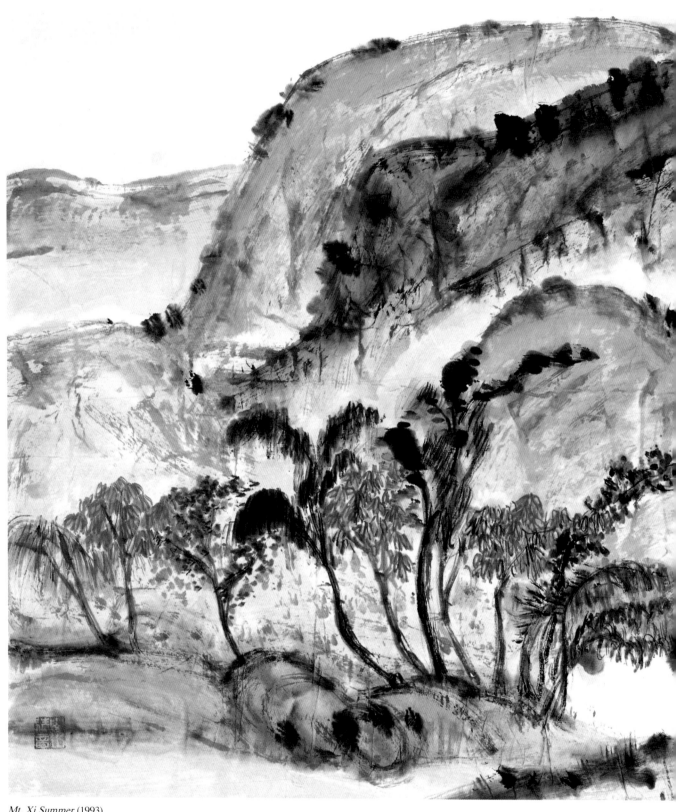

Mt. Xi Summer (1993)
溪山深秀
68×136 cm; 26.8×53.5 inch.

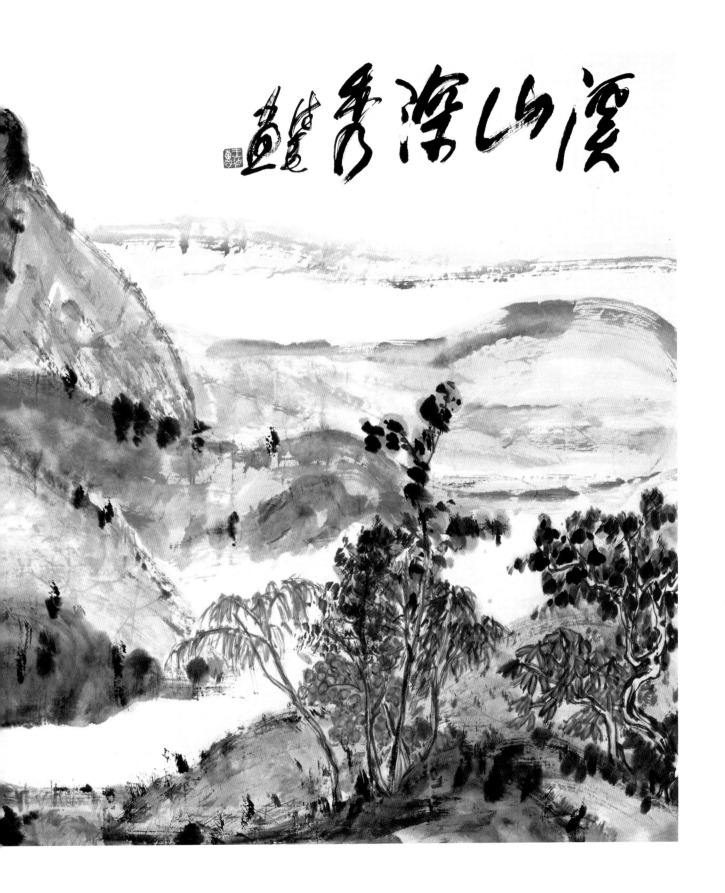

溪山深秀　崇　畫

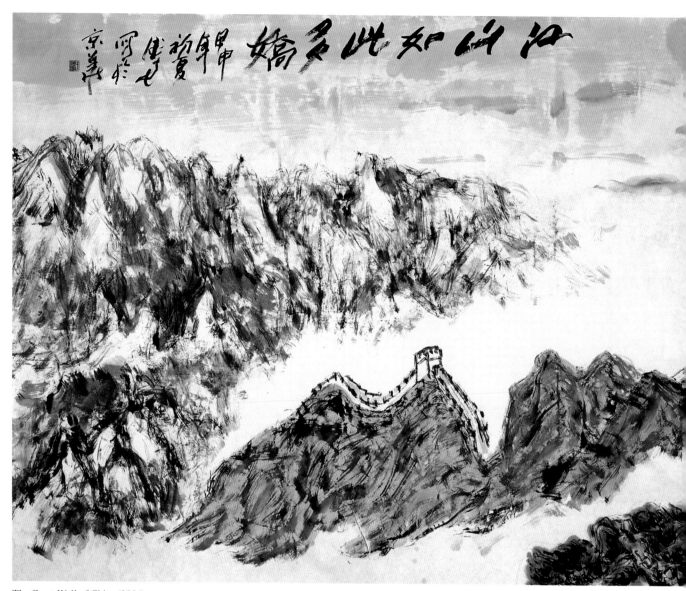

The Great Wall of China (2004)
江山如此多嬌
144×367 cm; 56.7×144.5 inch.

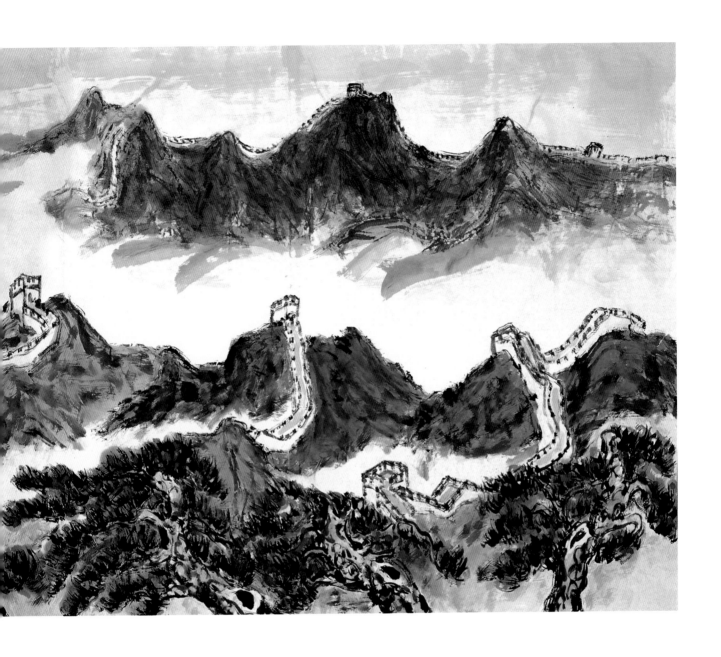

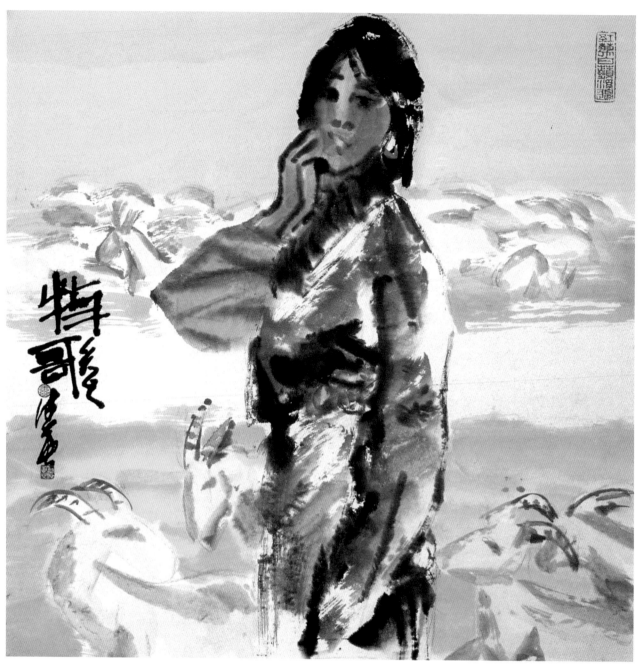

Shepherdess (1992)
牧歌
68×68 cm; 26.8×26.8 inch.

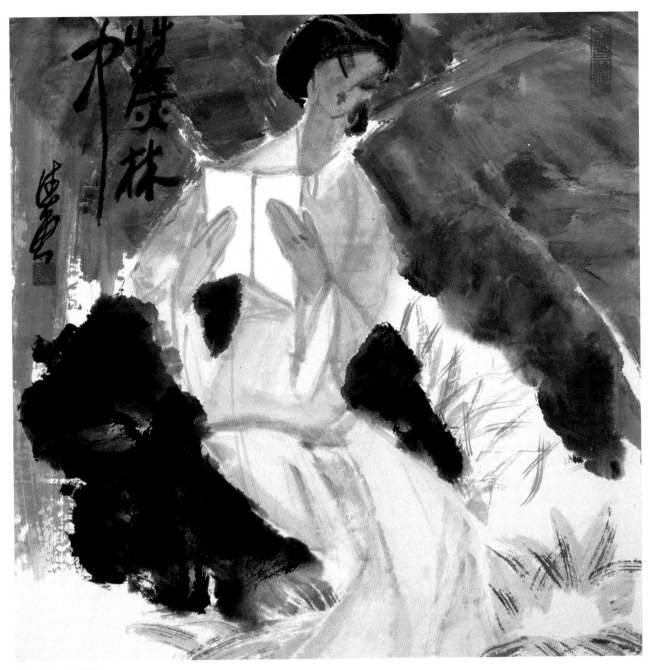

In the Woods (1995)
叢林
68×68 cm; 26.8×26.8 inch.

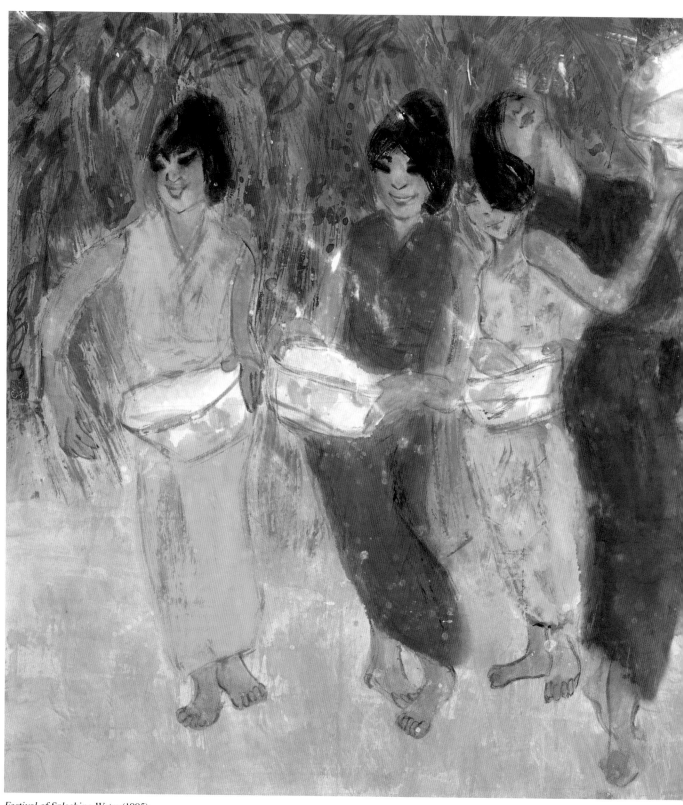

Festival of Splashing Water (1995)
潑水節
95×175 cm; 37.4×68.9 inch.

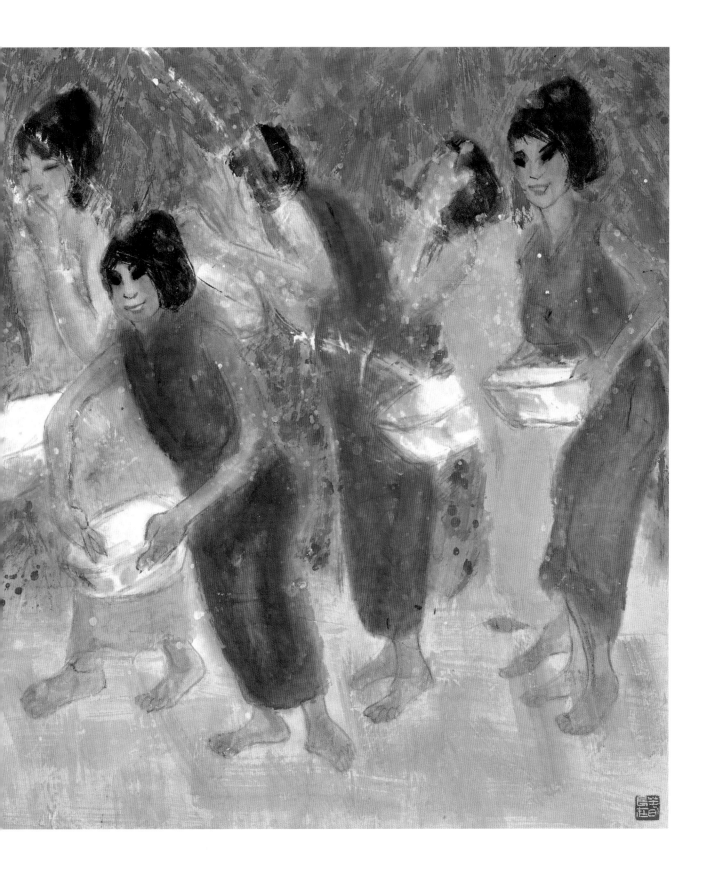

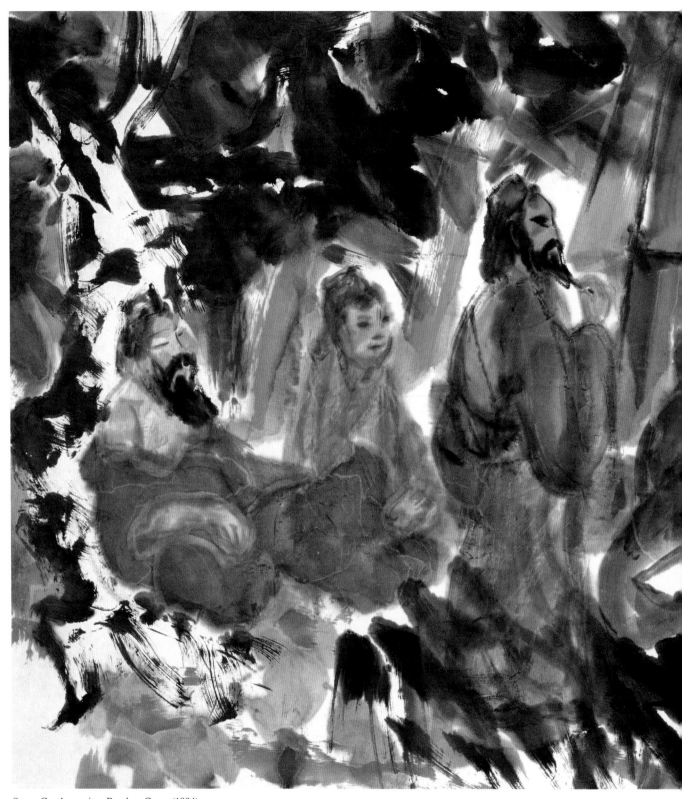

Seven Gentlemen in a Bamboo Grove (1994)
竹林七賢
95×175 cm; 37.4×68.9 inch.

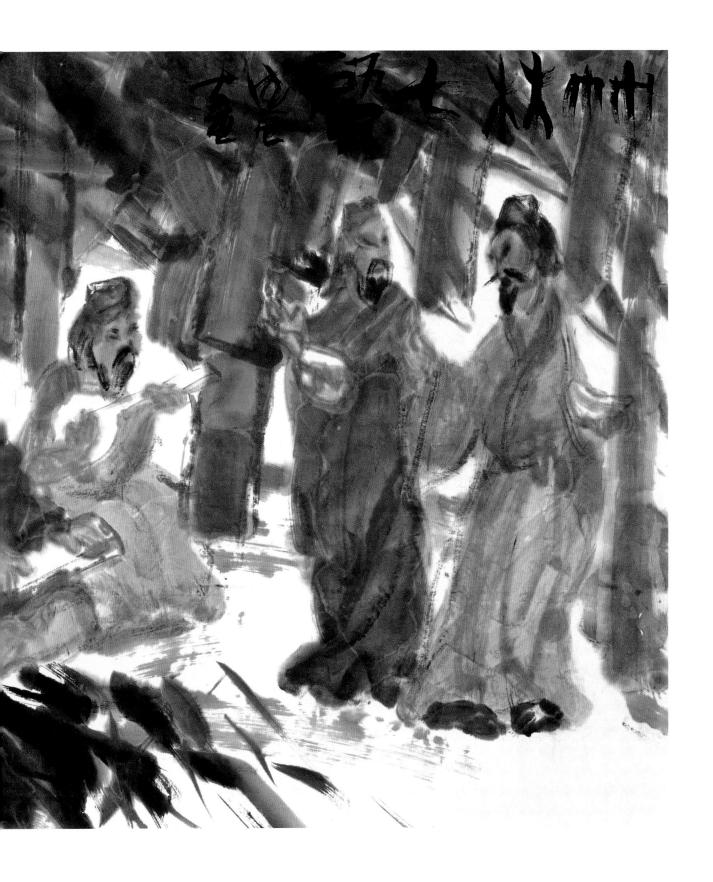

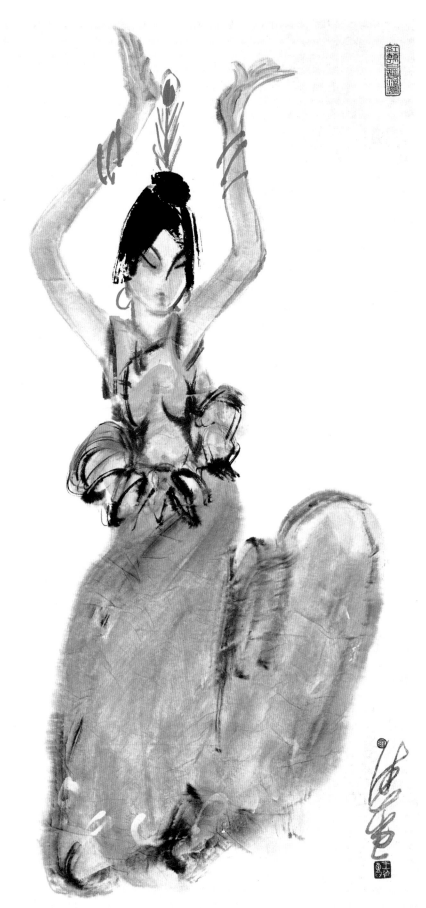

A Dancer (1994)
舞女
136×68 cm; 53.5×26.8 inch.

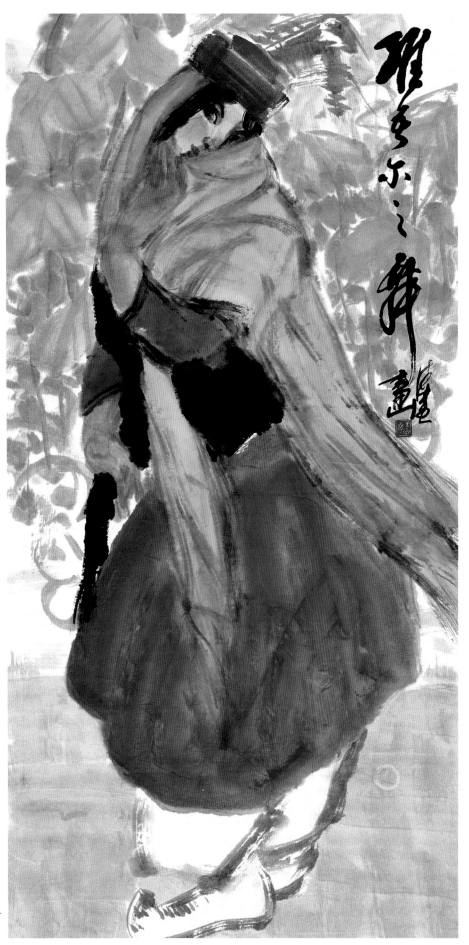

A Uigurian Dancer (1994)
維吾爾之舞
136×68 cm; 53.5×26.8 inch.

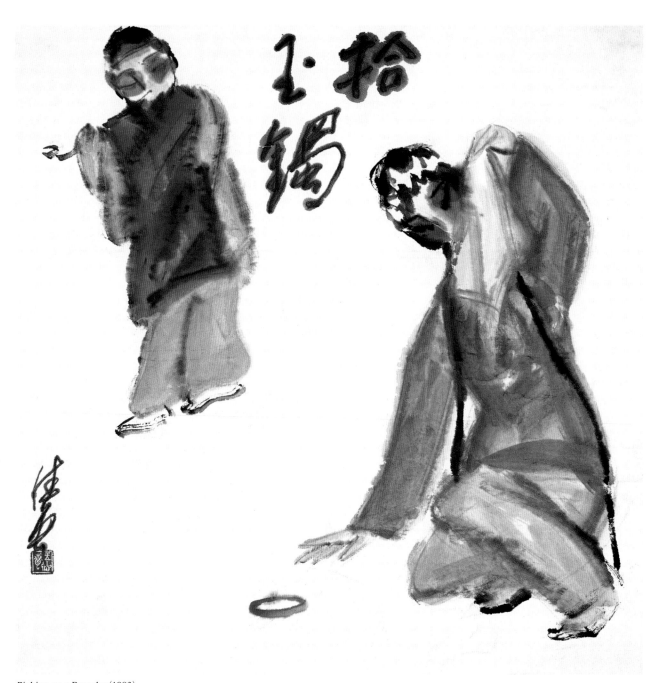

Picking up a Bracelet (1993)
拾玉鐲
68×68 cm; 26.8×26.8 inch.

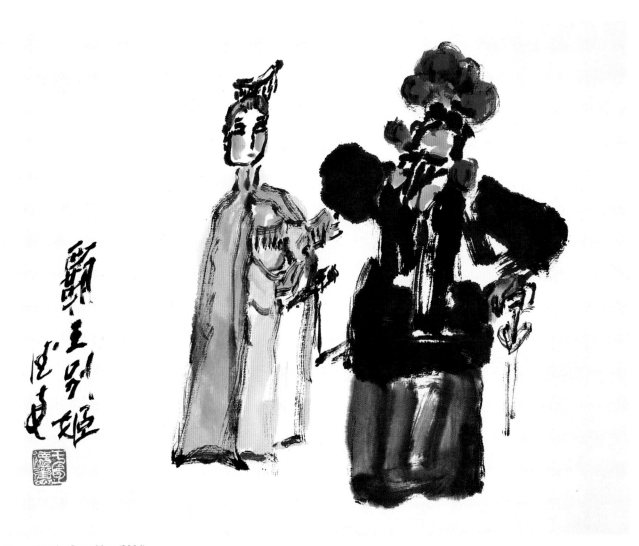

Farewell to the Concubine (2006)
霸王别姬
34×45 cm; 13.4×17.7 inch.

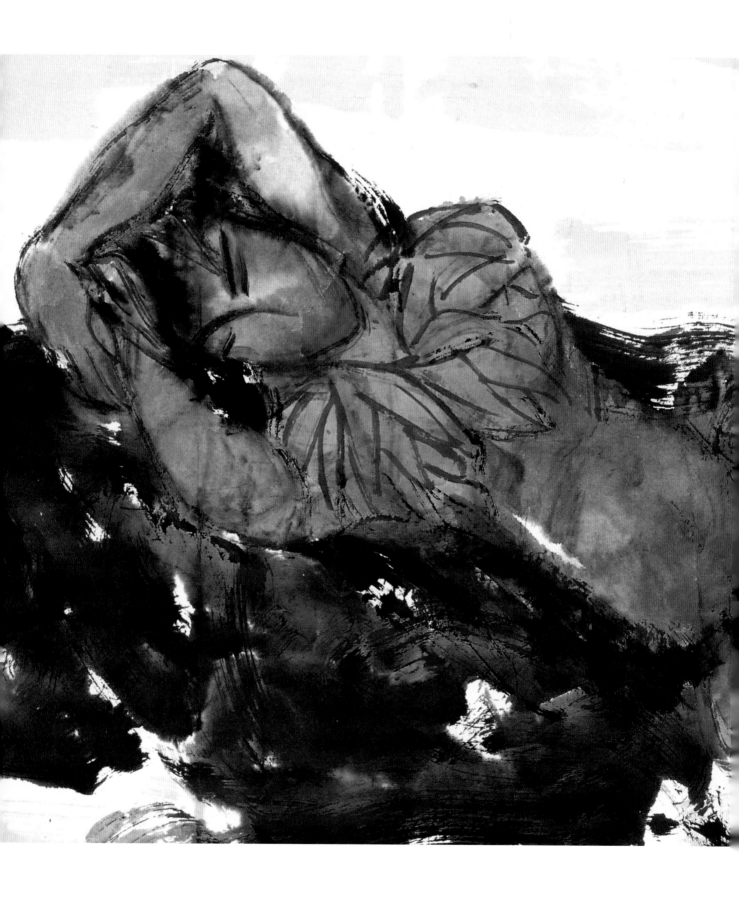

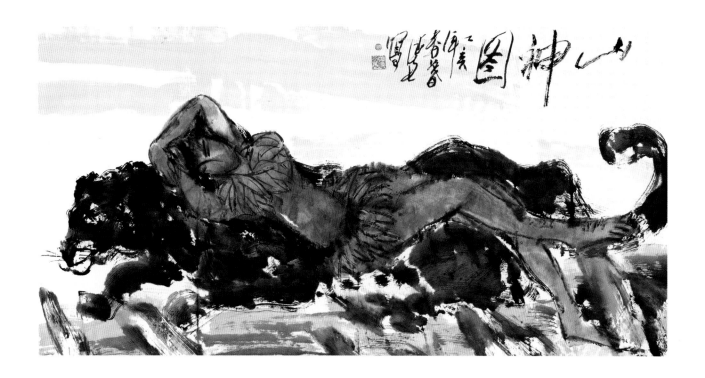

Mountain Goddess (1995)
山神
70×140 cm; 27.6×55.1 inch.

Left: Detail
左: 局部

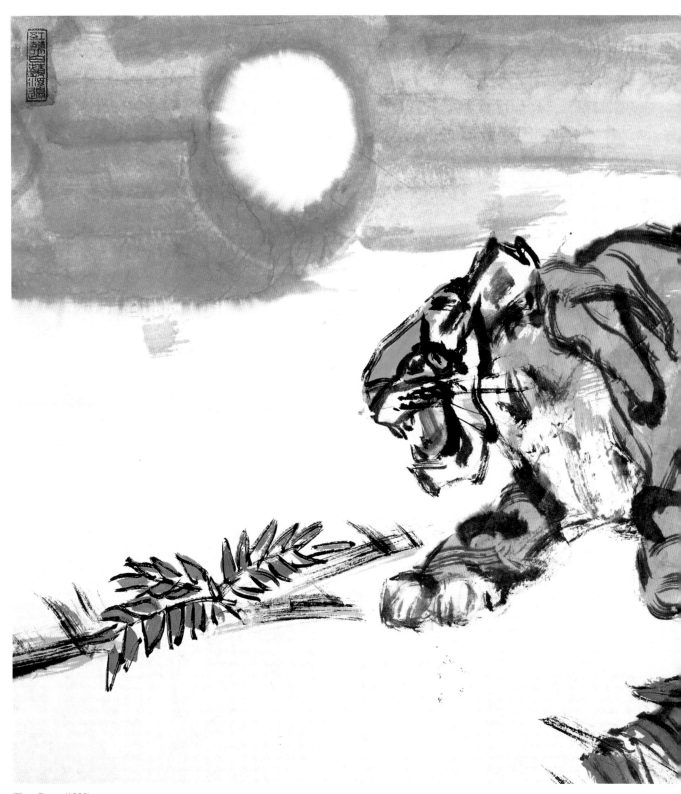

Tiger Roars (1998)
虎嘯風聲遠
78×148 cm; 30.7×58.3 inch.

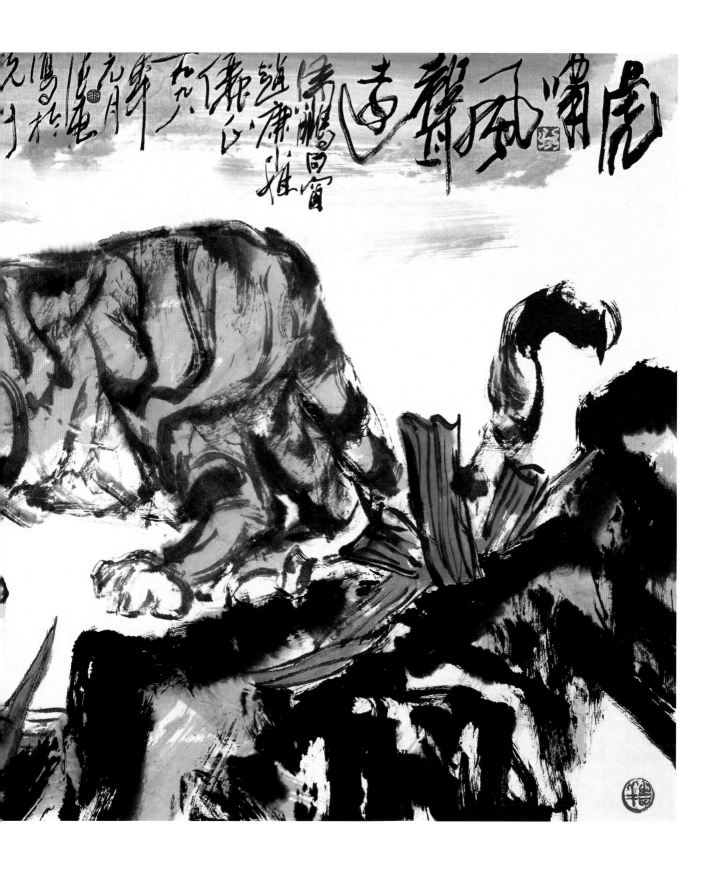

書 法
Calligraphy

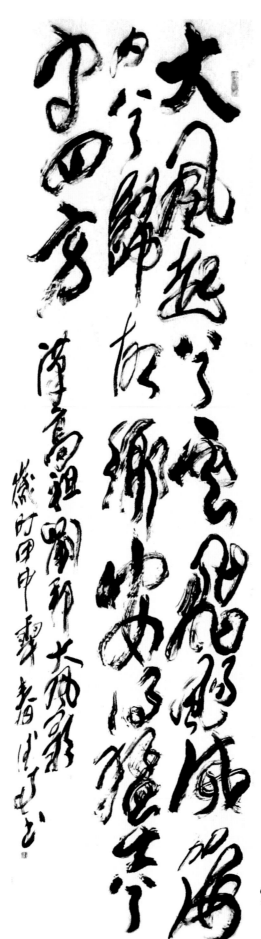

Calligraphy: Song of the Tempest (2004)
書法:《大風歌》

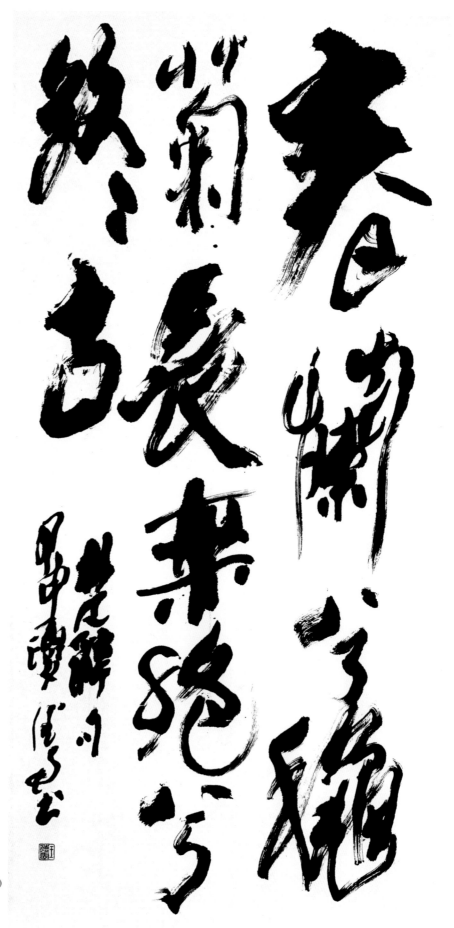

A Poetic Line from Chu (2004)
録楚辭
136×68 cm; 53.5×26.8 inch.

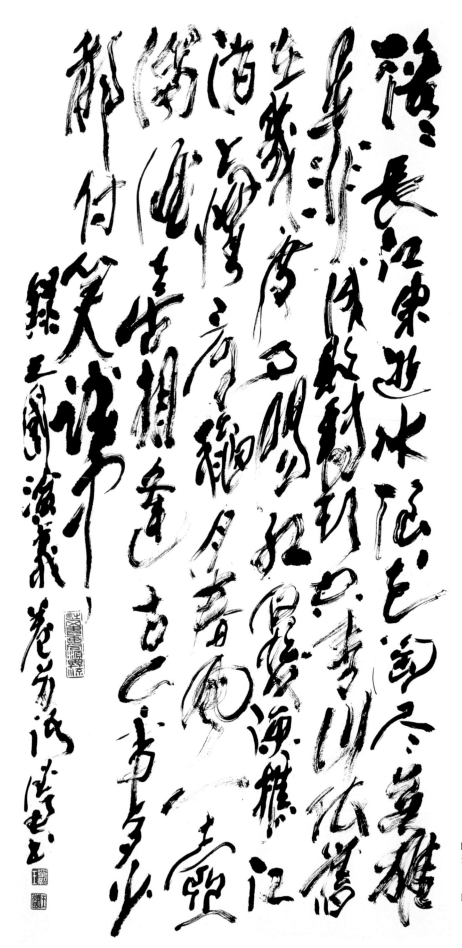

From *The Three Kingdoms* (2004)
錄《三國演義》卷首語
136×68 cm; 53.5×26.8 inch.

Right: Detail
右：局部

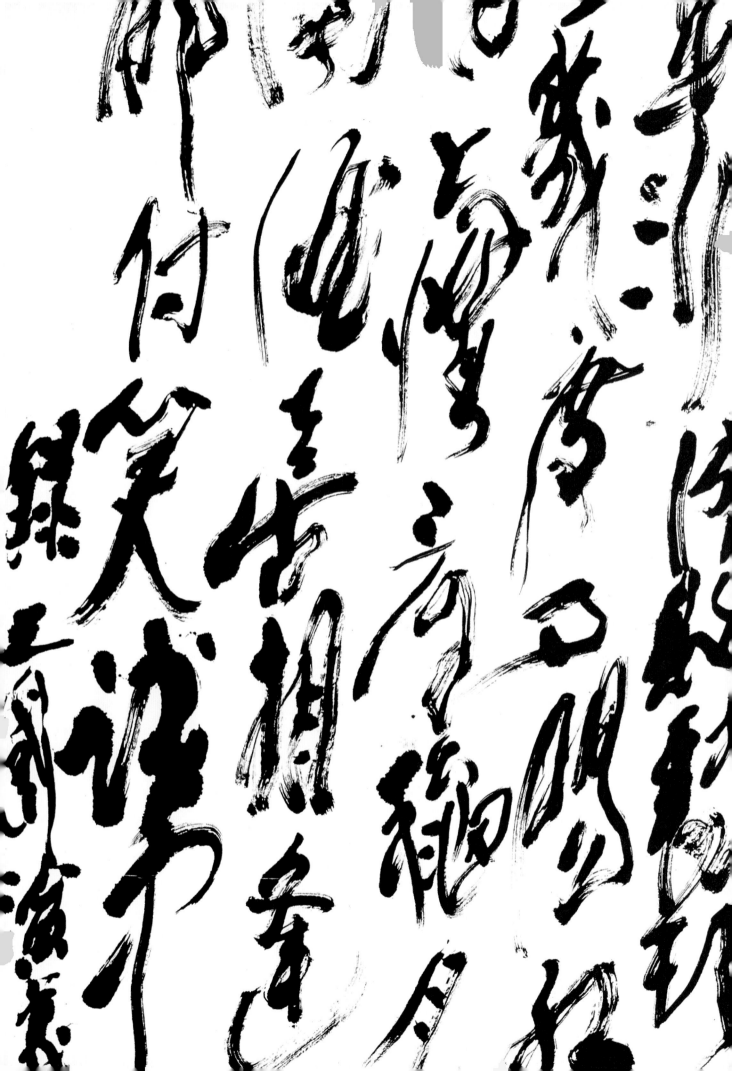

油畫
Oil Painting

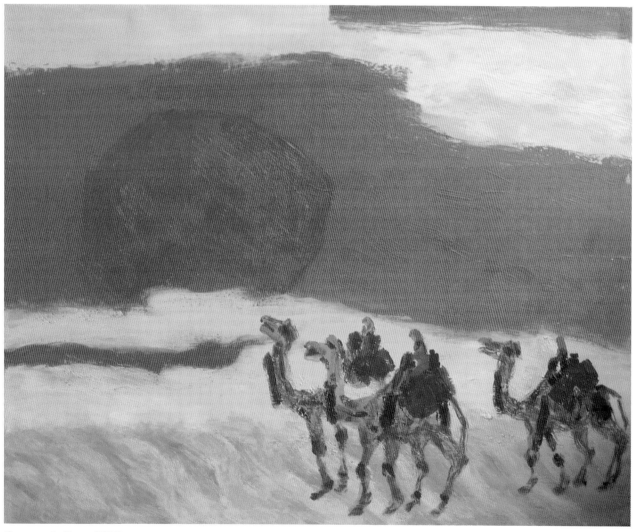

Sunset on the Desert (2005)
大漠日落
47×92 cm; 18.5×36.2 inch.

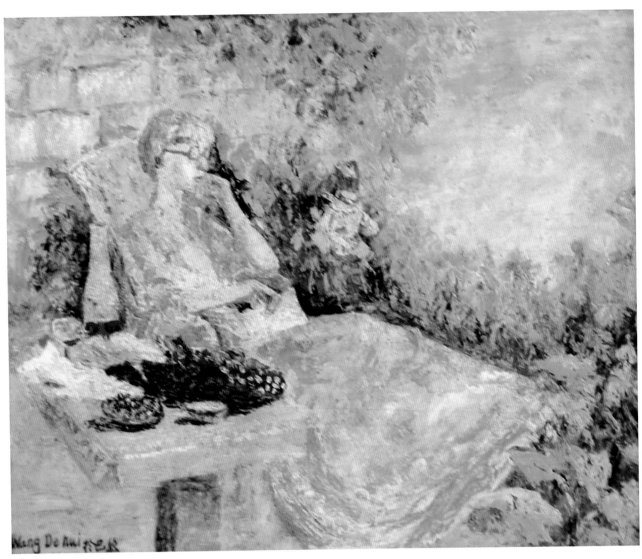

A Lady in Pink Summer Dress (1999)
穿粉紅色連衣裙的女人
50×60 cm; 19.7×23.6 inch.

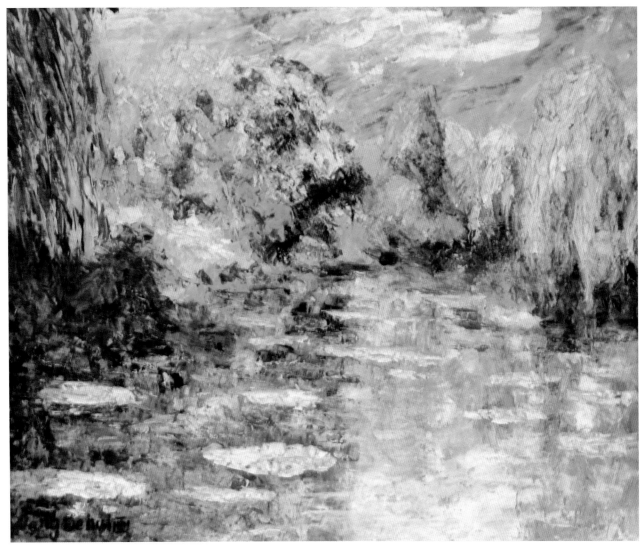

A Lily Pond in Paris (1999)
巴黎睡蓮池
50×60 cm; 19.7×23.6 inch.

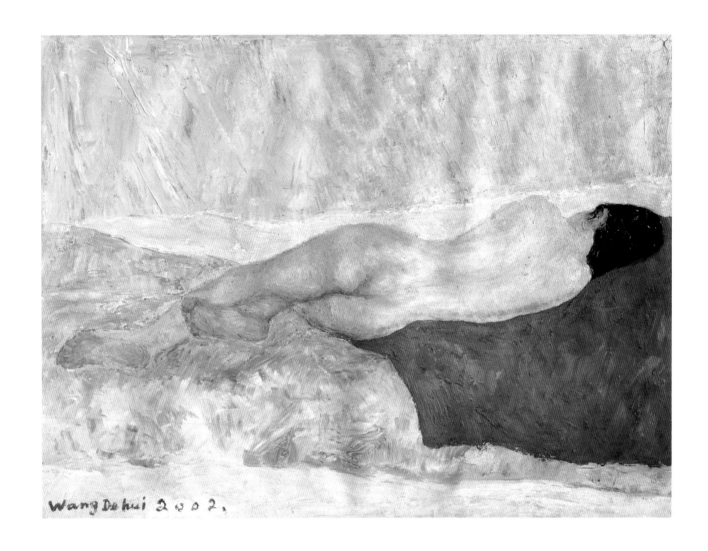

A Nude Woman Lying on Her Side (2002)
側睡女人體
58×78 cm; 22.8×30.7 inch.

Right: Detail
右: 局部

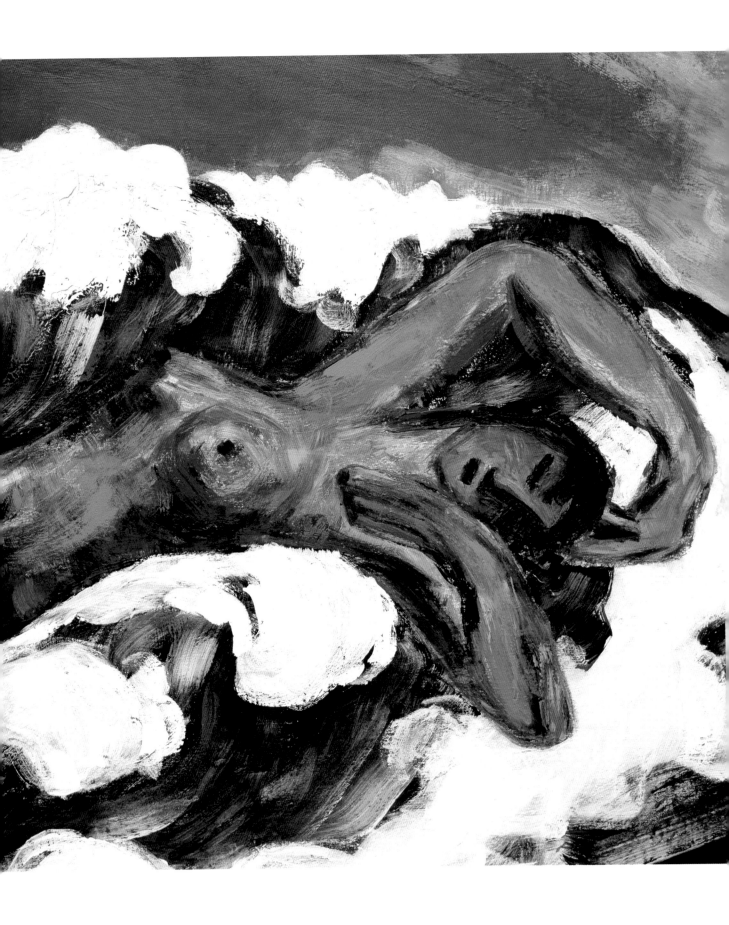

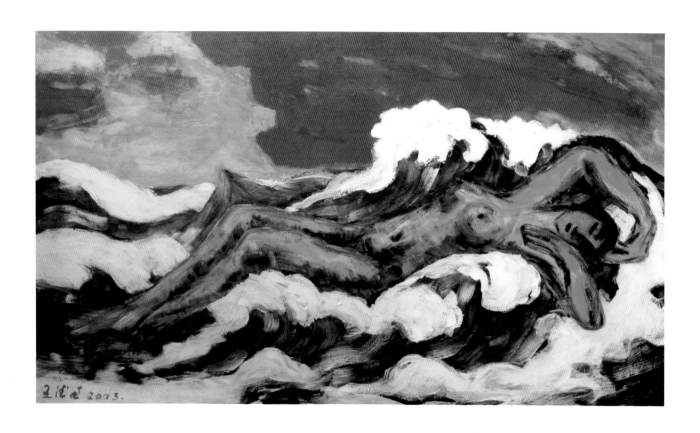

Stormy Ocean (2003)
大海風暴
90×160 cm; 35.4×63 inch.

Left: Detail
左：局部

Painting Index 作品检索

Acknowledgements

I wish to thank the TSAR Publications in Canada for supporting this international art project. My heartfelt gratitude goes to Dr. Lien Chao and Dr. Virginia Rock for their criticism of my paintings and persistent hard work to bring my art to print. I truly appreciate Prof. Wang Liu Qiu for his commentaries. I want to thank my classmate, fellow artist, Mr. Peng Ma for initiating this project and for overseeing its completion.

Wang Dehui
Tiantai, Zhejian, China
Summer 2007

衷心感謝

在《王德惠畫集》出版之時，我感謝加拿大TSAR出版社對這個國際藝術項目的支持。我衷心感激趙廉博士和弗吉尼亞·洛克博士對我的繪畫作品的評論，和她們爲讓我的藝術得以出版所付出的辛勤勞動。我感謝王流秋教授對我的作品的評語；我感激老同學、畫家馬鵬先生爲出版這本畫册所作的早期創議和持久的努力。

王德惠
中國浙江天臺
2007年夏